Darkroom Graphics

Darkroom Graphics

creative techniques for photographers and artists

Joanne & Philip Ruggles

AMPHOTO

American Photographic Book Publishing Co., Inc. Garden City, New York 11530

Library of Congress Catalog Card No. 75-1964
ISBN 0-8174-0573-9

Manufactured in the United States of America

Contents

Introduction

This book is directed toward a relatively large audience, composed of amateurs and professionals working in the broad field of the visual arts. Included here are photographers, artists, graphic designers, graphic artists and others who work to produce graphic imagery as a form of communications. The major objective of the work is to provide such people with a variety of creative photographic procedures to add diversity to their personal visual statements.

Interest in these creative photographic techniques has grown tremendously in recent years, but sources for such information are still quite scarce. For this reason we became convinced of the need for a book which would include data and information covering the films and other photographic products and equipment necessary to accomplish these creative graphic procedures. In addition, we felt it important to provide a text with accompanying illustrations that would stimulate interest in the production of personal graphic statements. Above all, we felt such a book should include a simplified step-by-step approach to the techniques utilized when working with such photographic products and equipment, so that persons interested in creative effects would find it possible to produce their own work and not simply view the results of our experimentation.

In the undertaking of this book, we have attempted to gather our experiences of the last eight years, utilizing thousands of sheets of film and printing paper, plus much trial-and-error experimentation, into a simplified and workable system. It has not been easy to differentiate, explain and classify the broad array of creative photographic procedures we have utilized into a single volume. Distinctions between the various techniques covered in this book are mainly for ease of discussion rather than to indicate any incompatibility between one technique and another.

We do not doubt that hundreds, even thousands, of other visual effects can be achieved by combining or adding to these indicated techniques in ways we have not even considered. Each time we work in our darkroom, new ideas come to mind for exploration. Some, of course, are doomed to fail; however, it is those ideas

which are successful, through this trial-and-error "fooling around" philosophy, that encourage us to continue. We believe that the most important key to really creative photo-related imagery is the "fooling around" approach. Certainly, the first idea or solution can be a good one, but very often, patient manipulation pays off with a truly unique image.

Keep in mind, as you apply these techniques to your own photographs, that no single technique will be successful with all subjects. A photograph which translates into a powerful high-contrast image may be very ineffective as a line conversion. A particular posterized image may be more dramatic in color than in black, white and gray values. An image which forms an exciting graphic statement in solarized form may be quiet and unappealing as a simple high contrast rendering. The important elements of creative selectivity cannot be minimized. Continual use of any one technique shows a lack of sensitivity toward the individual image—the technique has become a plaything. Certainly, proper selection and use of these techniques for adding dramatic appeal to carefully chosen photographic images should be your goal. We hope that this book will help you achieve it.

Basic Materials and Darkroom Techniques II

The major distinction between the photographic techniques presented in this book and those practiced in more conventional photography results, for the most part, from differences in photographic products rather than differences in available equipment or skills. Hence, almost anyone with a minimum of darkroom equipment, some general knowledge of photography, some interest in photographic experimentation and this book should be able to produce a variety of unusual photographic imagery.

High-contrast image of the Arch of Titus in Rome.

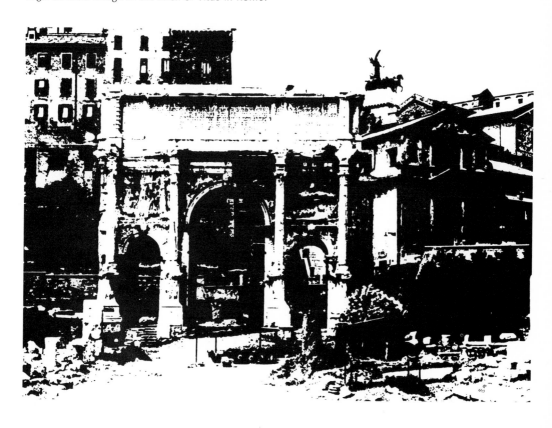

Throughout this chapter we will discuss the basic photographic equipment and supply areas, basic film, developer and safelight data, and related darkroom techniques which you should be able to use. Toward the end of the chapter the discussion will center around optional equipment, geared more for the advanced amateur or professional.

We believe that you will enjoy the images you produce using the material and data presented in this and subsequent chapters. There is nothing mystical about the production of such pictures.

BASIC EQUIPMENT NEEDED You should have the following basic equipment in your darkroom to be able to perform most of the manipulations described in the next six chapters:

Photographic enlarger (any size)

Interval timer (Time-O-Lite or similar)

Sweep-second timer (or kitchen clock with sweep hand, backed with dim light)

Film developing tank and reels (for continuous-tone film development)

Amber safelight (Wratten Series OC)

Red safelight (Wratten Series 1A)

Polycontrast filter kit

Four 8″ × 10″ developing trays

One 1-quart measuring graduate (plastic)

One 1-cup measuring graduate (plastic)

One medium-size funnel (plastic)

One photographic thermometer

Some method for darkroom contact printing (printing frame, flat board and glass, or other device)

Good pair of scissors

Good film squeegee (such as the Smoothee brand)

Two other equipment items not included in the preceding list but possibly of value are a light table and some type of film-registration system. It is possible to make your own inexpensive light table, and later in this chapter you will be told how to do so. There are many ways to produce an acceptable viewing system, but you can get along without one. Also described later in this chapter will be the set-up and application of a pin-registration system for film registration, necessary for the accurate placement of film images in exact, consistent relationship to one another.

It is possible to purchase most of the indicated equipment from your local photographic dealer. Keep in mind that many of these techniques, however, require the use of graphic arts supplies (and to a limited degree graphic arts equipment) and that access to a graphic arts supplier will be necessary. Most suppliers of graphic arts products are listed in the telephone book under that general classification, and are willing to do business with the general

10 DARKROOM GRAPHICS

public. They may also provide some technical help and advice, as will your local photographic dealer. Many photographic suppliers in the United States also hold franchise licenses to sell graphic arts products, so check with your local photographic dealer before going elsewhere.

You should have the following basic supplies available in your darkroom, and should understand basically how to use them:

Polycontrast (or other) projection printing paper
Kodak Dektol paper developer
Kodak D-76 (or other) black-and-white film developer
Indicator stop bath (or glacial acetic acid)
Fixer with hardener (separate containers for film and paper)
Farmer's Reducer (Kodak)
Chromium Intensifier (Kodak)
Small quantity of clear acetate or plastic sheet, about .005" thick
Film opaque and small brushes (for manual film correction)
Graphic arts (lith) film
Graphic arts (lith) developer

The last three items on this list may be purchased from any graphic arts supply house, as well as from many regular photographic dealers. Lith film and lith developer are most important for the image production described in the following chapters, and will be discussed in depth as to general working characteristics later in this section. Manual film correction techniques using film opaque will also be discussed later in this chapter.

It is important to have a good grasp of black-and-white photography before beginning these experiments; hence, we have included a general description of the exposure, development and printing of an acceptable continuous-tone image.

Using a high-speed black-and-white panchromatic film in the camera (such as Tri-X Pan film) and taking the pictures on a sunny day, out-of-doors, the resultant negatives record the different intensities of light which are reflected by the subject, pass through the camera lens and are received by the film. The amount of light acting upon the film determines the quantity of metallic silver in the film negative after processing. For example, if the subject photographed is wearing a white blouse or shirt, the negative produced will have considerable density in that area of the film, as most of the light reflected from the shirt will activate the silver in the film emulsion. Conversely, it follows that any black object to be photographed will absorb a large percentage of light, leaving less light to be reflected through the camera lens and recorded on the film. This reduction in reflected light will produce a less dense area in the developed film image. The rule throughout all types of

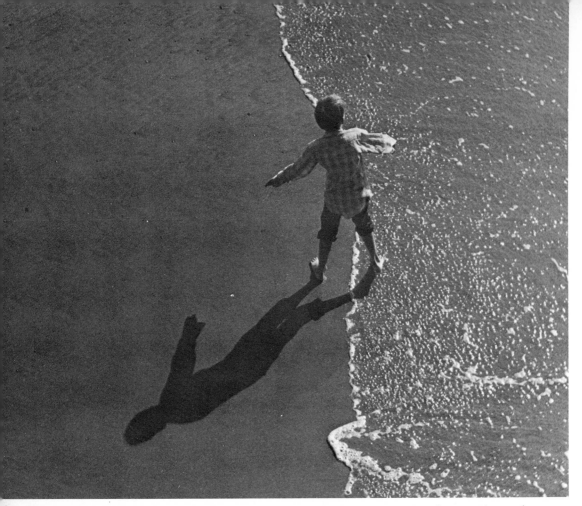

Continuous-tone print of a young boy at the ocean.

photography is that the reflectance of the subject will be recorded in reciprocal relationship on the negative. Then, assuming no variation in processing or printing, the final print will have the same densities when compared to the subject. Thus, highlight areas finally become whites, shadow areas become blacks and the many different grays translate accordingly. This is black-and-white continuous-tone photography.

When light acts at different levels in various places on the camera film through controlled exposure, it is the chemical reduction or film "development" that produces the visible range of blacks, whites and grays in the negative and later in reciprocal form in the positive print. Film development involves both physical factors (time, temperature and agitation) and chemical factors (dilution, replenishment and use), each of which plays a part in the final densities produced. The term "density" is a most important one, referring to the relative amount of silver produced by exposure and development.

There are many kinds of continuous-tone film developers, and most photographers select and work with only a few products in order to maintain consistency. Further information related to film and development will follow under the "Films" section of this chapter.

To summarize, continuous-tone black-and-white photography involves photographing a subject with a camera and recording that subject on film, in negative form, inversely to the amount of light reflected from the subject. This film image is then developed using strong chemical reducers which produce a visible negative pattern on the film. It is that film negative which is used, again with controlled exposure, to produce a positive print. The positive print should closely resemble the original subject photographed by the camera.

While conventional black-and-white photography produces a wide range of tones from deep black to extreme white, with many numerous value areas in between, high-contrast images have a much shorter scale. High contrast, by definition, is an image with only white and black representation in both the negative and the final positive print; this is, of course, reproduction of an image with literally no "shades of gray." Many of the techniques to be discussed in subsequent chapters of this book are intended for the

HIGH-CONTRAST IMAGES

High-contrast print of a young boy at the ocean.

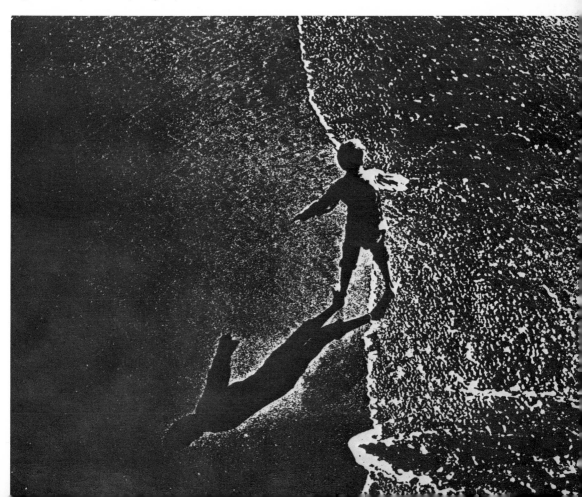

production of the high-contrast image; high-contrast image production is the starting point for a great many kinds of photographic manipulation.

The high-contrast image may be achieved in many ways, the easiest and best of which are discussed in Chapter III. We have found that the most convenient techniques to produce high-contrast imagery make use of graphic arts film and developer, commonly called "lith" (for lithographic) products. Basic working characteristics and use of lith products will be discussed in detail later in this chapter.

Basic Darkroom Information and Procedures

FILMS There are two major classifications of black-and-white films with which you should be familiar for the upcoming experiments: panchromatic and orthochromatic. Panchromatic, the first general classification, is most often used in the camera to record black-and-white imagery. "Pan" film is sensitive to all wave lengths of light in the visible spectrum, and records them as a wide range of tonal values on the film. Further, these various colors, at varying intensities, are recorded as shades of gray, thus providing a continuous-tone effect. Values run from black to white in gradual increments, providing many shades of gray.

Panchromatic film may vary in relative speed (or ASA) from 20, which is quite slow, to as high as 8000, considered exceptionally fast. The panchromatic films we have most often used are Kodak Tri-X Pan (ASA 400), which is a fast film, and Kodak Plus-X Pan (ASA 125), which is slower. With both types of films, and with most others in the black-and-white panchromatic classification, exposures may be made using normal lighting conditions, without the aid of a tripod, and under normal circumstances do not require any special exposure or lighting techniques.

Using appropriate developers, these films produce good fine-grain continuous-tone negatives. An important consideration to be made here is that "grain," or the size of the silver particles on the negative, is roughly proportional to the relative speed of the film emulsion. The general rule is that the faster the film (i.e. the higher the ASA number), the more grainy the negative; the slower the speed, the less grainy the negative image. Hence, the use of faster films offers advantages relative to exposure yet disadvantages when considering the quality of the negative and the final printed image. Normally grain problems are more evident with smaller format cameras, such as the 35mm, due to the extreme enlargement required when printing the negative to positive form. Fortunately, you will find that such grain problems will not present difficulties when converting your images from continuous-tone form to high contrast. Nearly any size con-

tinuous-tone negative will produce a suitable high-contrast image.

The second classification of black-and-white film that must be discussed here, which will be used frequently throughout this book as the basis for many of the procedures, is orthochromatic "lith" film. Such films are used for high-contrast work in the graphic arts industry and have little sensitivity to red light, thus providing ease in exposure and processing under red safelight conditions. Orthochromatic lith films are manufactured under many different brand names, some of which are: Kodalith (Kodak), Cronalith (DuPont), Formolith (Ilford), Reprolith (GAF) and Gevalith (Agfa-Gevaert). Another group of films closely associated with lith films is the "line" film series. These are also orthochromatic and used in the graphic arts somewhat interchangeably with lith films. Both types are used with process cameras to photograph two-dimensional images in the form of type matter or designs (known as line work). With special screens, the films are used to reduce continuous-tone photographs to dot patterned images called halftones.

It is also possible to purchase high-contrast lith films with a panchromatic emulsion. These are sensitive to all wavelengths of light and must be exposed and processed in total darkness. Our use of such panchromatic lith films is limited, and for practical purposes, all references to lith films in this book will be directed toward the orthochromatic type unless otherwise specified.

Lith film is exceptionally slow in emulsion speed, with an ASA rating of between 10 and 40, and therefore has the fine grain necessary for good image resolution. When used with lith developers, it produces a very limited range of grays as compared with conventional panchromatic films which produce a continuous-tone image. Lith film is a "short scale" film whereas panchromatic film is considered a "long scale" film. One important difference between lith film and panchromatic film is that lith film may be processed under red safelight, providing exceptionally convenient working conditions for exposure and development, while panchromatic films must be handled in total darkness.

It is possible to purchase lith films in 35mm size, usually in 100-foot rolls, for exposure using a camera and tripod. This technique will be discussed in Chapter III. We do not recommend this application because the film is exceptionally slow, requiring lengthy exposures; also, it records all reds as blacks.

Lith films are normally purchased in sheet form, usually 50 or 100 sheets to the box, in standard sizes beginning with 4″ × 5″ and going upwards through 5″ × 7″, 8″ × 10″, 10″ × 12″, 11″ × 14″ to 20″ × 24″ and larger. Lith film is not exceptionally expensive when compared to continuous-tone film used in the camera. The structure of the film includes the orthochromatic film emulsion coated on an acetate, polyester or plastic base, with a dye coating

on the opposite side to stop light bounce. This antihalation backing, on the base side of the film, is removed during processing of the film. Generally lith films are sold in thicknesses ranging from 0.002″ to 0.011″; we recommend that you purchase the normal thickness of 0.004″, either on polyester or acetate base. Film costs vary according to the type of base support used, with polyester providing greatest dimensional stability at, of course, the highest cost. Acetate-based film will probably be suitable for the bulk of the work we describe.

For the most part, the procedures and techniques to be discussed in this book make use of lith films and lith developers, although original (camera) negatives will be exposed and developed using familiar continuous-tone film and developers. Where deviations in films and processing are necessary, they will be thoroughly discussed.

DEVELOPERS There are literally dozens of developer formulas available to the photographer, each with a specific purpose. We have found that limiting our developers to three general classifications helps us to control consistency of results and avoid confusion in the darkroom. It is certainly possible to use developers other than the ones we recommend here, but we believe that the ones which we will describe are easily obtained and most workable in the darkroom situation.

Continuous-tone film developers: This class of developer is used to develop most types of black-and-white film, such as Tri-X Panchromatic and Plus-X Pan. We have had consistent success with Kodak D-76 film developer, which is intended for general photographic work and produces moderately fine-grain results with most films. Another popular developer is Kodak Microdol-X, which may be used in much the same way with excellent results. Regardless of the type of continuous-tone film developer you select, it should produce a fairly long scale of tones in your negatives.

Continuous-tone film developers will not be used with lith films, even though it is possible to produce very fine grain images with them. One major problem which occurs if continuous-tone developers are used to develop lith film in the tray is that an undesirable "chemical fog" is produced. Also, continuous-tone film developers do not produce the high contrast and density desired in lith film images.

Printing paper developers: We have had good results with Kodak Dektol developer, which we use primarily with Kodak Polycontrast enlarging paper. Dektol is designed for tray use and will produce a beautiful scale of tones from a continuous-tone film negative. We have limited almost all of our photographic printing to the Polycontrast paper with Dektol developer because

of good exposure control, ease of processing, and excellent values from black to white.

Our experiments will make use of Dektol developer for paper development as well as with lith films to a limited degree. Thus, we recommend the following dilutions of Dektol with water:

Dektol 1:1—For high-contrast prints on Polycontrast papers
Dektol 1:2—For normal printing of continuous-tone film
Dektol 1:5—For the posterized image on lith film (Chapter V)

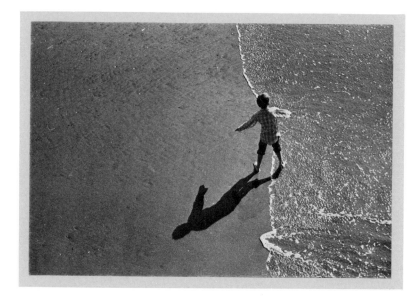

This lith film positive was developed in full-strength Dektol. We do not recommend this technique in the production of high-contrast imagery because the results approach continuous tone.

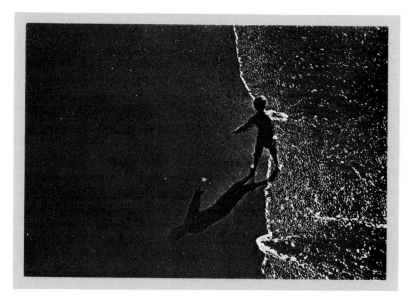

This lith film positive image was developed in lith developer after exposure from a continuous-tone negative. We recommend this procedure because the resultant imagery is much more contrasty and has better density than the Dektol-developed film image.

It is possible to use Dektol, and other paper developers, with lith film to develop a high-contrast image; however, the images produced using this combination will have lower contrast. There will be a good range of value, almost continuous-tone, though less than that of the continuous-tone original image. We do not recommend the use of Dektol for the production of high-contrast images on lith films for this reason. However, because Dektol provides definite steps of tone with lith film, you will note that it is used to produce the posterized composite negative. Further information will be provided on posterization in Chapter V.

Lith developer: This third general classification of developers is designed specifically for use with lith and line films and may be purchased commercially under such trade names as Kodalith, Cronalith, etc. Lith developer is a hydroquinone-formaldehyde-based product designed to produce maximum image density in a moderately short tray developing time. Such developers may also be used with high-contrast printing papers, also a graphic arts product, usually used by printers for the proofing of line work and halftones. We will make little use of such high-contrast papers in the procedures described in this book.

Lith developer may be purchased in either powder or liquid form, with our preference to the liquid type for ease of mixing. The developer will always be purchased and stored in separate containers, parts "A" and "B," and will not be mixed together until immediately before use. If purchased in liquid form, both "A" and "B" must be diluted with water before use, usually on a three part water to one part developer mixture; thus, one gallon of concentrated liquid "A" will provide a total of four gallons of diluted solution. We strongly recommend that lith developer not be mixed in concentrated form, but be diluted before the combination of parts "A" and "B." The final "working solution," placed in the tray, will be a 1:1 mixture of *diluted* parts "A" and "B."

It is possible to mix and store lith developer in diluted form, such as one gallon each of diluted "A" and "B" in separate containers. If stored as diluted solutions, they should be used within a few months from the initial dilution date. When working with the developers, be very careful not to contaminate or mix even a small portion of "A" with "B" (or vice versa), as developer wear-out begins immediately upon contact of the solutions. For darkroom use, equal proportions of diluted "A" and "B" are mixed in the tray, thus beginning immediate developer action and producing a solution with short tray life. Developer wear-out is indicated by a brownish-yellow discoloration of the solution.

The following step-by-step procedure describes the use of lith developer in the normal darkroom situation. Remember that you will be working under red safelight (Wratten Series 1A or similar) so that it will be possible to watch the film throughout processing.

The technique described will be for a properly exposed 8″ × 10″ sheet of lith film.

1. In normal light, mix 4 ounces of dilute "A" with 4 ounces of dilute "B" in a beaker or mixing cup, and place this 8 ounces of solution into the left hand 8″ × 10″ tray (in your row of three 8″ × 10″ trays). More developer may be used if desired, or added to this developer as the solution begins to wear out from use. The developer should fully cover the bottom of the tray.

2. Working under red safelight, expose the lith film sheet using the enlarger and proper techniques (descriptions following). Now immerse the exposed lith film sheet, emulsion side (light side) down, in the developer, as evenly as possible. After a few seconds, flip the film sheet over so that it develops emulsion side up, even though the image may appear wrong-reading. (*Note:* We do not recommend the use of gloves or mechanical devices when working with developer. Under usual circumstances, lith developers will not cause skin rashes or other problems. However, should you find that you are beginning to develop an unfavorable skin reaction traceable to the highly alkaline developer, consult a physician and wear rubber gloves when doing tray development.)

3. Begin agitating immediately, slowly rocking the tray in a manner which is easiest for you. Agitation should be frequent and consistent, and must be continued throughout development to ensure a properly developed image.

4. Time of development is normally from two to three minutes, with a visible image usually appearing after 30 to 45 seconds from the initial immersion of the film in the developer. Temperature throughout development should be 68°F. (20°C.), though a slight difference in temperature will probably not cause exceptional image or density problems.

5. It will be necessary for you to visually judge the density of the image under red light conditions as the film develops. It is possible to do this either as the film rests in the tray, while agitating, or to remove the film from the tray carefully holding the film sheet over the tray and between you and the safelight. As development progresses, the black areas of the film will become darker, and reach a good density after about 2½ minutes under normal conditions. Because lith developer is intended as a tray developer, little chemical fogging will occur, even with considerable overdevelopment. In fact, we will recommend overdevelopment to compensate for underexposure in specific instances.

6. The second tray in the three-tray arrangement should contain an indicator stop bath or a solution of dilute acetic acid (a common stop bath formula is 4 ounces of 28% acetic acid combined with 32 ounces of water). The purpose of this "short stop" solution is to ensure the complete neutralization of the developer, and to provide long life to the fixing bath. To use the

bath, the negative should be removed from the developer and carefully placed into the stop solution, making certain that both sides of the film are covered. Neutralization will occur immediately and the development action will be stopped. It is important to note that you should not place a negative wet with short-stop solution back into the developer as the solutions will mix and cause the developer to deteriorate. If you wish to inspect the negative for possible continued development, a water rinsing bath should be used in place of the short stop, to remove the developer from the film surface, thus allowing for an extended visual inspection under red light. The negative may then be reimmersed in the developer without contamination.

7. When proper density is attained, maximum development time under usual circumstances being about four minutes, the film should be removed from the developer and quickly placed into the stop bath for neutralization. Short stop is very inexpensive but a water bath may be used if the acid is not available. The negative should remain in the stop bath for about 30 seconds.

8. The last 8″ × 10″ tray in the series will contain a photographic fixer. We prefer a "rapid fixing" product, but any fixing bath will prove suitable. The fixing bath may also contain a hardening solution which is added to harden and condition the film emulsion, but this is not a necessity. Carefully immerse the negative in the fixing bath, making certain that all parts of the film sheet are under the surface of the solution, and allow the clearing action to begin. This will be visually evident by inspection of the film in the red light, with a fresh fixing bath normally producing initial clearing 15 seconds after immersion. When clearing begins, the room lights may be turned on and the film inspected for density. Never attempt to redevelop the film once it has been placed in the fixing bath, as the fixer will ruin the developer. Allow the film to remain in the fixing bath for twice the amount of time required for full clearing.

9. After full clearing, place the film into a running water bath for approximately 10 minutes, then squeegee carefully to remove excess water and hang to dry.

10. It is best not to handle the film until it is completely dry.

One gallon each of dilute "A" and "B" developer will provide enough solution to process about 60 sheets of 8″ × 10″ lith film. You will find that best results will be obtained when proper time, temperature and agitation techniques are used. This is very important and will be discussed later in this chapter.

There are other high-contrast developers available, which may work suitably with lith films. Such developers, usually available from your regular photographic dealer, are products such as Kodak D-8, D-11, D-19 and others. Keep in mind that these developers are not intended to produce the great density that lith

developers provide, and are intended more for higher contrast continuous-tone negatives. Our best results have been with lith developers.

We recommend the use of lith films and lith developers for all high-contrast manipulations in this book because optimum results may be obtained with minimum effort. Lith materials produce excellent high-contrast imagery with reasonable exposure and processing techniques. They also provide extremely high density images, thus allowing for chemical film reduction with Farmer's Reducer to correct for poor image quality. Chemical reduction and intensification of lith film images will be discussed later in this chapter.

Our own photographic printing involves the use of Kodak Dektol developer and Kodak Polycontrast printing papers. With these products, we have been able to produce prints containing deep blacks and clean, crisp whites. We have not often employed graded printing papers, that is, numbered papers which produce only a single degree of contrast, nor specialized photographic papers or developers for the production of high-contrast images.

PHOTOGRAPHIC PRINTS

Autoscreen conversion of a high-contrast statue image. The even dot pattern here is produced when Autoscreen film is applied to an already high-contrast image. Refer to Chapter VI for further information.

It is possible to purchase graphic arts printing papers from your graphic arts supplier. Such products may be developed in lith developers and are intended for high-contrast work only. Also, certain types of stabilization papers, such as the high-contrast Kodak Ektamatic series, are available, but these require controlled machine processing.

Remember that we use Dektol diluted one-to-one with water for high-contrast printing and Dektol diluted one-to-two for general continuous-tone printing. Further information on the printing of high-contrast images and the posterized print will be provided as those subjects are discussed in their respective chapters.

DARKROOM SAFELIGHTS

There are two types of safelights that you will need to carry out the darkroom experiments described in this book. The amber safelight (Kodak Wratten Series OC) is the most common, and is used in most conventional darkrooms. Many varieties of amber safelights may be purchased from your photographic supplier. Amber lighting is used with Kodak Polycontrast and other projection speed printing papers.

The second type of safelight is the red one (Kodak Wratten Series 1A), which is used with all orthochromatic materials including lith films. A less expensive substitute for this safelight is the red incandescent bulbs made especially for this purpose by GE and Sylvania. It is important not to attempt to use any ordinary red incandescent bulb such as those sold in hardware stores; these are intended for decorative lighting only, and will probably not be safe for use in the darkroom.

In any case, safelights tend to fade with age and if there is any doubt of the one you have, it should be tested before use. One suitable test is done in otherwise total darkness, with access to the switch controlling the red safelight source. Take a sheet or a scrap piece of lith film from the film box, trimming it to approximately 4″ × 5″ and place the remainder back in the box. Lay this small piece of film on a dry working surface in the approximate center of the darkroom. The film should be emulsion side (light side) up, which may be checked quickly when the lights are first turned on. Over this piece of lith film, center a coin, such as a quarter, and turn on the red safelights in your darkroom, to simulate normal working conditions. Allow this set-up to remain absolutely stationary for four minutes under the red light, then develop the sheet of film as you normally would in lith developer, fix and wash. Examine the film sheet carefully for film fogging or overall grayness and, if any is evident, investigate for light leaks or other safelight problems. A similar procedure but using projection paper and Kodak Dektol developer may be used to test your amber safelight system.

Working under suitable red safelight conditions, lith film can

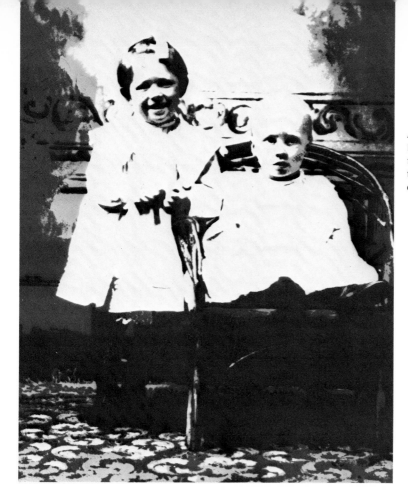

Annabelle and Rupert Henderson's Kids. The four-tone posterization technique is discussed in detail in Chapter V.

be handled under ruby light for minutes at a time without adversely affecting the film emulsion. It is recommended that you keep your safelight sources at least four feet from the film to minimize fogging possibilities and that you avoid excessive exposure of lith film to large amounts of red light unless absolutely necessary.

TIME, TEMPERATURE AND AGITATION AS DEVELOPMENT CONTROLS

Temperature when developing should be held to 68°F. though you will find that a three-to-four degree shift either up or down will produce only slight changes in the density. The higher the developer temperature the faster the development occurs, producing greater density and image contrast; cooler developers retard image development and yield slightly lower relative density and contrast. If you desire to control temperature accurately, use a photographic thermometer for temperature readings, and place the tray containing developer inside a larger photo tray containing water of the desired temperature. Ice or hot water may be used in the outer tray to bring the developer temperature to the desired level. If you purchase powdered developer, remember that mixing requires very hot water and, if just mixed freshly, some chilling process must be utilized before the solution may be used. We have found that room temperature, usually 68–72°F. is acceptable for most lith film development. Stop baths and fixing agents, the

remaining two processing solutions, will work fairly well at almost any room temperature, but best results, likewise, will be had at 68–72°F.

Agitation while developing is also of importance. Normal agitation, which is the type that we recommend, calls for manual rocking of the tray using opposite tray sides or corners in alternating fashion, at a rate of from 15 to 20 rocks per minute. Agitation at a faster rate may cause very fine areas of the film image to be overdeveloped and "plugged"; "still" development, without agitation, causes less development of the very fine areas of the film image, and sometimes a loss of density. There are other undesirable chemical effects which result from lack of agitation while developing, such as bromide "drain" and developer streaks.

Time controls for development have already been discussed to some degree. Most lith film images will begin to appear, with normal exposure, between 30 and 45 seconds after development begins, and will gain density until a maximum is reached, in approximately $2^1/_2$ to 3 minutes. Overdevelopment is sometimes necessary to compensate for underexposure, and is possible with lith developer due to its slight fogging action, but is not recommended as a normal procedure. Lith film has good development latitude to compensate for both under- and overexposure. Exposure data will be provided later in this chapter.

Film density can be judged by holding the dry film between you and a 100-watt incandescent light bulb. If light is visible through the black areas of the film, density is not as high as it should be. The film image, however, may still be usable. If small "pinholes" are evident, opaque can be used to cover them. The technique of manual film correction will be discussed later in this chapter.

LITH DEVELOPER EXHAUSTION
Exhaustion of lith developer begins immediately upon mixing the two parts of "A" and "B" together, and may be somewhat compensated by shifts in development time and exposure; however, overuse of this is not recommended.

Under normal circumstances, lith developer exhaustion will be caused by use, developer age (if stored in diluted form for long periods of time), developer oxidation (if stored in open containers), contamination (such as fixer getting into the developer by accident), and strong light. We have found that a good rule of thumb in determining developer life is that 8 ounces of developer (4 ounces of "A" and 4 ounces of "B") will develop two sheets of 8″ × 10″ lith film, with large black areas, to the desired density.

If you attempt to use lith developer after it is exhausted, indicated by a pronounced brownish coloration of the solution, the images produced will lack blackness and may be "fill-in" in the finer image areas. A second general rule to follow here is that

lith developer may be considered worn out when developing time for a normal negative or positive is 50 percent longer than with fresh developer; normal development time as specified in most manufacturers' film data sheets is 2½ minutes with all variables controlled. Miserly use of lith developer does not pay in terms of wasted sheets of film and time.

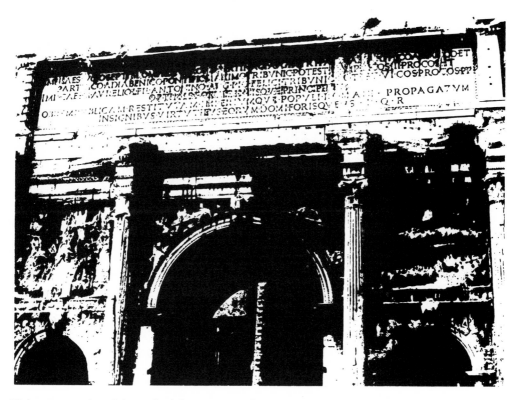

High-contrast print of the Arch of Constantine in Rome.

Related Darkroom Techniques

The reason for film contacting is to allow you to produce images of opposite tonality; that is, a negative will contact to produce a positive and, conversely, a positive will contact to make a negative. Use of this process will be an integral part of many of the procedures described in later chapters of this book.

DARKROOM CONTACTING SYSTEMS

There are three basic types of contacting systems. They are the contact printing frame, found in many darkrooms, a simple glass-board system and a vacuum-frame system. Each has advantages and disadvantages and each allows production of negatives and positives of good quality. Good film contacting requires the

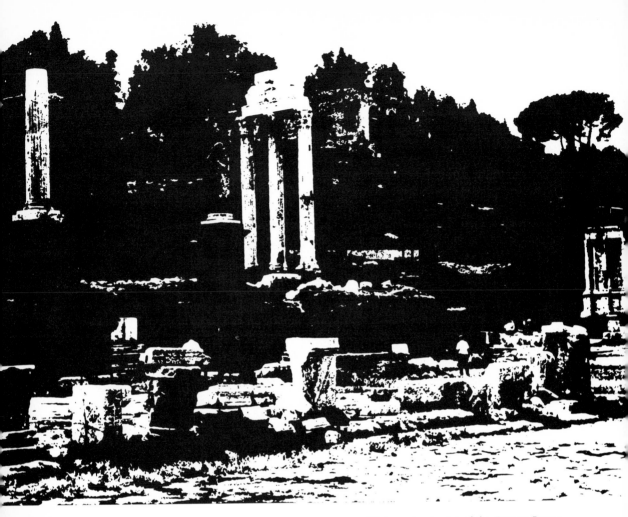

High-contrast print of the Roman Forum.

very tight "sandwiching" of films, otherwise the resulting film images will be blurred.

The conventional contact-printing frame, which is found in many photographic darkrooms, is a pressure type of contacting system. It consists of a wooden frame with glass on the front side, and a removable hinged wooden back with metal clamps to insure tight film-to-film contact. All films are placed between these surfaces so that the emulsion of the unexposed lith film sheet may receive its exposure through the film containing the desired image. One disadvantage with this type of contacting system is that it is generally limited to smaller film sizes; large printing frames are expensive and not often available. A second disadvantage of the contact-printing frame is that it is difficult to maintain precise register using register pins (registration is the alignment of images in relation to one another, and the pins are the devices used for such alignment, discussed in detail later in this chapter), as no provision is made in the frame for such devices. It is possible to substitute a "tape registration technique" in place of

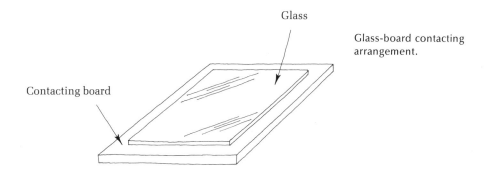

Glass

Glass-board contacting arrangement.

Contacting board

the pin register system, by placing masking tape exactly where desired and aligning the edges of the film to the tape guides. This system, however, is not foolproof and may result in misregister; extremely accurate registration of film images will be necessary for a number of the techniques described, especially the posterization technique (Chapter V). A third disadvantage is that the contact-printing frame is somewhat awkward when used to receive projected film images on lith film held in the frame. Advantages, of course, are that many darkrooms are already equipped with them, and that they are convenient and produce good contact between emulsions.

The second type of contacting system can be made quickly and easily, at little expense. It consists of a flat piece of hard wood or masonite of workable size, say 17″ × 22″, and painted black or covered with a dark, nonreflective pigment, with an accompanying piece of single or double strength glass, approximately 16″ × 20″. The hard wood baseboard should be thick enough to be

Contact frame or printing frame (back views).

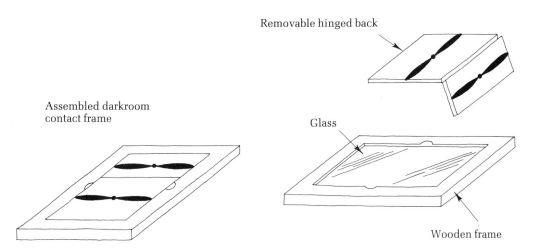

Removable hinged back

Assembled darkroom
contact frame

Glass

Wooden frame

inflexible, and can have painted guides, outward from the center, to indicate film sizes such as 4″ × 5″, 5″ × 7″, 8″ × 10″, 11″ × 14″ and so on.

To use the system for film contacting, the hard wood board would be placed over the baseboard of the enlarger, and an unexposed sheet of lith film placed emulsion side (light side) up on the dark board surface, under red safelight. The painted marker indications ensure accurate film placement. Over this unexposed film sheet would be placed the high-contrast negative (to be contacted to positive form), facing the emulsion of the imaged negative to the emulsion of the unexposed lith sheet. Over these contacting pieces of film the glass, scratch-free and clean, is now carefully positioned, with the weight of the glass creating sufficient contact between the two films. Edges of the glass may be protected with masking tape for safety. An exposure, using the enlarger as the light source, will now be made. For exact step-by-step procedure here consult the technique for making a lith film contact described later in this chapter.

One advantage of this system is that it is not expensive to set up because it makes use of very easily obtainable products. A second advantage is that pin-register systems may easily be used with this system, producing excellent results. A third advantage is that the glass-board procedure may also be used for the exposure of silk-screen films, in contact with lith film positives, as discussed in Chapter VII. The major disadvantage is that the glass is subject to breakage in continual handling. Also, the device is sometimes awkward and bulky when working in smaller darkrooms. But we use such a system continually in our own darkroom and are very pleased with the overall working characteristics and the results we obtain.

The third type of contacting system is by far the most expensive, yet the most desirable if extremely accurate results are wanted. It consists of a vacuum board, usually made of wood or metal, with small holes over the entire surface. The board is then connected by flexible hose to a vacuum pump, very similar to a vacuum cleaner motor; when the pump is turned on, air is pulled inward through the holes in the frame surface, thus drawing to its surface whatever might rest on it. Usually such a system requires the use of a sheet of clean acetate, plastic or polyester, trimmed to the maximum dimensions of the board, to be placed over the surface while the vacuum is engaged, so that the "drawdown" is tight and full advantage is taken of the suction.

To use the system, a sheet of unexposed lith film is centered emulsion up on the board and the vacuum motor started. Over this is the film image to be contacted, placed emulsion down, and then over these two pieces of film is positioned the sheet of clear acetate, to ensure tight contact of the film pieces. Exposure for the

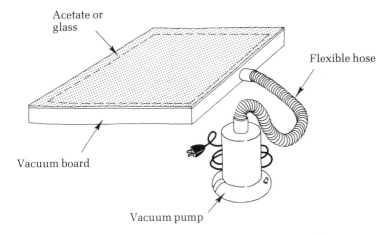

Acetate or glass

Vacuum board

Vacuum pump

Flexible hose

Vacuum frame-contacting system.

indicated time is made using the enlarger as the light source.

We have investigated a number of vacuum contact-frame systems, and have used such systems for some of our work. The major drawback to the vacuum system is expense, as prices generally begin somewhere over $100. Another disadvantage is that the acetate sheet used to cover the contacted films is easily scratched and must continually be replaced.

Overall, we believe that the best results with the least expense will be produced using the glass-and-board system. It is the system used in the data sheet information presented throughout this book.

It is most important that you understand exactly the technique for making a lith film contact, before beginning any darkroom manipulations. For example, let us assume that you want to contact a high-contrast film positive to negative form on lith film, and then use the produced negative in one-to-one contact to produce a photographic print on Polycontrast paper. We will describe only the lith contact technique here, using a red safelight and the glass-and-board system for contacting.

MAKING A LITH FILM CONTACT

1. In normal room light, move the enlarger head to its uppermost position and insert the largest empty negative carrier available with your enlarger. Set the timer for 30 seconds and, with the largest lens provided with the enlarger (to accompany the largest negative carrier), set the aperture to $f/16$. It is important to point

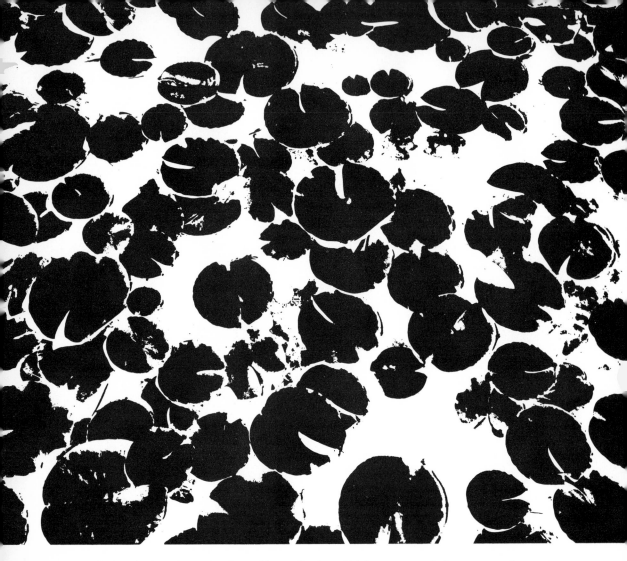

Black-and-white abstraction formed by application of high-contrast technique to a continuous-tone photographic image of lily pads.

out that all exposures should be determined empirically using "test strips," described later in this chapter, or from previously established exposure data. If the exposure time used is too short, the resultant image will lack density; if the exposure is too long, the resulting image will appear dark, blurred, and somewhat out of focus. Upon close inspection with overexposure, you will notice that the dense black areas appear to have "bled" out into the clear parts.

2. Working under red safelight, center a piece of unexposed lith film on the dark board surface, light side up. Over this piece of film, lay the film positive image which you desire to print to negative form. The positive should be placed over the unexposed sheet of lith film with the emulsion down (dull side of a sheet of processed film viewed under reflected light is the emulsion side). This procedure, called "emulsion-to-emulsion" contacting, is preferred because the spread of light due to the thickness of the

film base will be minimized, an important consideration if the images on the film contain extremely fine lines or dots. Always be sure that the unexposed lith film sheet is exposed emulsion up, light side toward the enlarger light source. If not, the antihalation layer coated on the back will absorb light, thus producing no image with the usual lith film exposures. Very long exposures will penetrate the antihalation base, but are not recommended.

3. Place the clean glass over these two pieces of film, allowing the weight of the glass to exert a downward pressure. This should provide ample pressure for good contact.

4. Expose the film for the desired time, that is, $f/16$ for 30 seconds.

5. Develop the sheet of exposed film in lith developer for about $2^1/2$ minutes, or until the desired density is achieved, then short stop, fix and wash. Turn on the overhead white lights, first making certain that the box containing the unexposed lith film is closed and light-tight.

6. Wash the film negative for 10 minutes, squeegee and dry.

7. When dry, visually inspect the film negative for "pinholes" in the black areas or for other areas which lack density. Correct manually with opaque, a technique described later in this chapter, or remake the negative with more or less exposure.

It is very important to remember that contacting provides a reversal of tonality; that is, a negative image produces a positive and a positive image produces a negative. It is possible to find special films which produce a negative from a negative, or a positive from a positive, but these films require light sources different from the usual enlarger incandescent type and, in many cases, different developers to produce suitable results. By far the simplest technique is to produce positives and negatives using the contacting system previously described.

A similar system will also be used with images projected by the enlarger. To do this, the film is centered on the board and the glass is then placed over it to hold it securely. The film negative, located in the negative carrier, is then projected to the lith film sheet using exposure and aperture information, found by a preliminary test. If the image is a high-contrast negative, you will find that a stop of $f/16$ and an exposure of approximately 30 seconds should provide a good starting point. Using this system, with the projected image, tonality of the image is also reversed. Later we will discuss using this technique to produce extremely large, high-contrast images and, in some cases, as a film saving technique (Chapter III). As you will note, this projection technique as described is very similar to printing the continuous-tone film image on Polycontrast paper, like the normal darkroom procedure.

It is essential to keep your equipment clean and dust-free, as

dust causes pinholes in film images. If you neglect this precaution, you may have to do an unnecessary amount of manual film opaquing on every film negative or positive produced in your darkroom. Not only does such film correction require considerable time, but it can also involve much tedious detail work.

LITH FILM
REDUCTION AND
INTENSIFICATION

Chemical film reduction and intensification are normally sequential operations. Film reduction is first used with lith (and other types) of films to correct for unwanted "gray areas" carried over from the continuous-tone original, or to reduce the overall blackness or density of the image. Under normal circumstances, the density produced with lith films is not intended to be reduced or limited, so film reduction is not used for that purpose; however, when producing the lith film conversion positive from the continuous-tone negative, invariably some amount of "excess grayness" remains at image edges. To remove this unwanted tone, chemical reduction using Farmer's Reducer is used. Film reduction has been used for nearly all the high-contrast examples in this book.

Intensification, the second technique in the series, is normally utilized to increase density in the film negative or positive and makes use of a chromium intensifier solution. You will probably find that image intensification will not be used very much in the production of high-contrast images using our described techniques, because lith films produce extremely high density when properly exposed and developed. Chemical reduction to remove unwanted gray image areas will not greatly affect the overall density of the lith negative or positive.

To summarize, film reduction using Farmer's Reducer will be used a great deal to remove undesirable gray areas from the film negative or positive, or to correct for considerable overdevelopment, while film intensification will not be used very often with lith products because such intensification is seldom necessary. Beginning with film reduction and then progressing into film intensification, each technique will be discussed in step-by-step form.

Reduction is a chemical process which utilizes two major chemical ingredients: (1) sodium thiosulfate, normally called "hypo," and (2) potassium ferricyanide. It is possible to purchase a "matchbook" type packet of Farmer's Reducer at most photographic supply stores, containing separate, premeasured envelopes of powdered hypo (part A) and potassium ferricyanide (part B). These packets are manufactured by Kodak under the name "Farmer's Reducer," after Howard Farmer who originally developed this reduction technique. The matchbook packet is mixed with water to provide a total of 32 ounces of solution.

It is possible, even recommended, to purchase each of the ingredients separately in larger quantities at your photographic

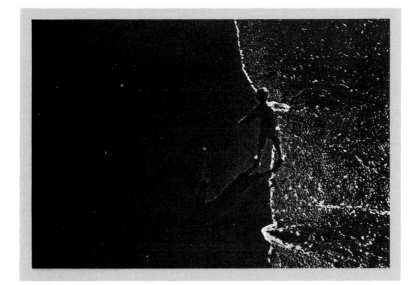

Lith film positive developed in lith developer.

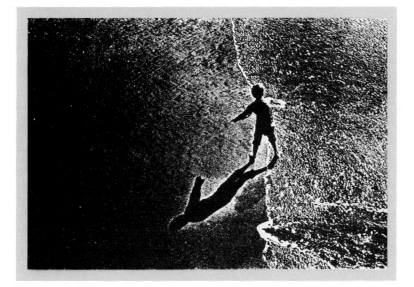

Lith film positive developed in lith developer then reduced with Farmer's Reducer to increase the contrast.

supplier, and mix them as follows: For part A mix $6^3/4$ ounces of sodium thiosulfate with enough water to make 32 ounces of solution. For part B mix $^1/4$ ounce of potassium ferricyanide with enough water to make 32 ounces of solution. The two solutions must be kept in separate containers until immediately before use, and should be mixed in equal 1:1 proportions. If you desire to reduce in one area only (called "local reduction"), the mixed reducer solution should be diluted one part to ten parts water, and applied to the emulsion side of the film image with a cotton swab.

Under normal conditions, after initial mixing of the two ingredients, the tray life of Farmer's Reducer is about 10 minutes. If you purchase the matchbook type, instructions will be provided with the package.

The following procedure should be followed closely to reduce a lith film negative using Farmer's Reducer:

1. Begin by soaking the high-contrast negative in water for at least 10 minutes to soften and condition the film emulsion.

2. Select the smallest tray able to accommodate the entire film sheet. If working in the 8″ × 10″ size, use an 8″ × 10″ tray; if working with 4″ × 5″ negatives, then use a tray which approximates those dimensions or slightly larger.

3. Carefully measure out 4 ounces of part A and pour it into the 8″ × 10″ tray, then measure out 4 ounces of part B and mix it with the A in the tray. Eight liquid ounces should be enough solution to cover the bottom of the tray.

4. Remove the negative from the water bath and place it emulsion up into the solution. Begin to agitate immediately upon contact of the film with the reducing agent. Farmer's Reducer may be used under normal room lighting conditions, allowing visual inspection as the reduction occurs.

5. As reduction begins, carefully inspect the areas you desire to remove, agitating constantly. Normally reduction occurs quickly, with the majority of density being removed while the Farmer's Reducer is fresh. The solution will generally remain active for about 10 minutes. Should the desired image effect not be achieved with the initial bath (it usually is), fresh reducer should be mixed and the reduction process continued.

6. After a few minutes the unwanted gray areas will disappear, at which time the film sheet should be removed from the reducer and placed back into the water bath.

7. The reduced negative should then be placed into a running water bath for from one to five minutes, then fixed in an acid hardening bath, or a regular fixing bath if hardening solution is unavailable, for 10 minutes. If the negative is to be intensified this fixing process should be omitted.

8. Wash the negative for 15–20 minutes before drying.

It is most important to point out that once a negative or positive has been properly reduced, all film and paper images made from that negative or positive will be fully high-contrast and will require no further reduction. Hence, we strongly recommend that you reduce your negatives and positives as early as possible in your image conversions, thus saving reduction time, and possible image problems, later on. Also, if you reduce the positives produced from your first high-contrast image conversion (various techniques are discussed fully in Chapter III) you will often be able to work with smaller film sizes, saving time and chemicals.

Chemical intensification, using Kodak Chromium Intensifier, will now follow if necessary. To determine if the intensification procedure is needed, visually inspect the black areas of the film negative or positive to determine the amount of "hiding power" of these sections. A lack of density is normally indicated by a weak, light gray area or areas which should be black, with an abundance of pinholes evident. Keep in mind that lith films, processed in lith developer, produce maximum density and that some amount of film reduction is possible without the necessity of intensification.

If intensification is required, wash the negative thoroughly; traces of hypo from the reducer can cause loss of image. As with Farmer's Reducer, which can be purchased in packet form at most photographic supply houses, Kodak Chromium Intensifier is also available in a small package. A packet of intensifier contains two envelopes of powders: bleach bath and clearing bath. Each of the baths should be mixed in a separate container with 16 ounces of water. The procedure for film intensification is as follows:

1. Position four trays in the darkroom area where the work is to be completed. In the first 8″ × 10″ tray place the bleach bath. The second tray, preferably a larger tray such as 10″ × 12″ or 11″ × 14″ in size, should be half full of water. The third tray, again an 8″ × 10″, should contain the clearing bath. The final tray in the series, also an 8″ × 10″, should contain Dektol developer, mixed 1:1 with water to total 8 ounces of solution. The second tray containing water will serve as a rinse tray between steps.

2. Place the negative into the bleach bath, where a color change will occur, resulting in the black negative areas turning yellow. This process normally takes from three to six minutes and, as with reduction, may be done in normal room lighting.

3. When a maximum yellow is achieved, rinse the negative in the water bath for about 30 seconds to neutralize the bleach bath.

4. Now place the negative into the clearing bath and allow it to remain there, with agitation, until the yellow stain has been replaced with a nearly white image in the original black areas. The action normally takes from two to five minutes, after which time the negative should again be rinsed in the water bath to neutralize the clearing bath. Washing for 30 seconds is sufficient.

5. At this point the white negative should be developed in a low-sulfite developer, such as Dektol mixed 1:1 with water, until maximum blackness in the image areas is attained. Such development, with agitation, normally takes from two to four minutes. Overdevelopment is not possible.

6. After development of the negative, now black in color and intensified, it should be washed in a running water bath for 10 minutes and dried. Fixing is neither necessary nor recommended.

Upon inspection, if the density of the negative is not as great as desired, the complete intensification technique may be repeated

until the desired image density is produced. Both the bleach bath and the clearing bath may be stored in separate containers and reused a number of times. You will find that the package of Kodak Chromium Intensifier will provide basic information concerning this procedure.

MANUAL FILM CORRECTION Both reduction and intensification are negative-positive correction techniques which involve the use of chemical action. However, manual correction procedures are also possible.

In instances where the negative or positive image areas lack density, due to pinholes or as a result of underexposure, underdevelopment, dust or other particulate matter in your darkroom, manual correction with a liquid opaque may be more practical than intensification. Such opaque is sold in many forms, and we recommend that you purchase a small jar of water-based red clay or black graphite types, normally one to three ounces in quantity. Cost is very low and a single jar should provide ample opaque for hundreds of film negatives and positives. You should also purchase two or three inexpensive artist's brushes, with pointed tips, from very fine to medium.

To complete opaquing, work at a window on which the negative is held, or on a light table (see later in this chapter how to make an inexpensive type), and apply the opaque on the base (nonemulsion) side of the film. Thus if you should over-opaque an area, it will be possible to remove that opaque after it has dried by simply scratching it away from the film base surface, whereas opaque on the emulsion side of the processed negative will have a dull appearance with reflected light.

The opaquing solution itself should be thinned out adequately, so that it has good "hiding power" to cover the pinholes. It dries quickly and completely in a minute or so after application. For use, it is simply painted evenly over those areas which lack density and through which light would pass; it should not be applied in such a manner as to "build up" on the film surface, as this will retard drying and waste opaque. With opaque it is also possible to make image additions, applying it just as an artist would paint on a canvas, to change an image as desired. In making such manual image changes, keep in mind that the tonality of the image, that is, whether it is negative or positive, will dictate the changes which are required.

A second type of manual film correction involves the removal of the emulsion from the negative or positive by scraping, usually with a sharp knife or razor blade. This technique is somewhat difficult to control as the scraping action may produce scratchy image edges. However, manual removal of emulsion is often used to delete entire sections of an image. With this technique, be certain to watch the amount of pressure applied to the knife or

razor blade, as well as the number of times the scraping action is used. If too much scraping is done, the film base will become translucent and will transmit too much light. This could cause problems when printing the negative or positive.

Throughout the experiments in this book you will be required to make test strips to determine basic exposure times. The technique is simple and should become part of your basic darkroom procedure, especially when first undertaking these projects.

In nearly all of the techniques described in this book, you will be using your enlarger, and will be making test strips, in one of two ways: (1) using the enlarger as the means of image projection with a film negative (or positive) in the negative carrier, onto lith film or printing paper, or (2) using the enlarger as the light source for contact printing.

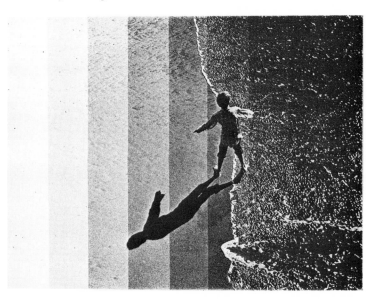

Positive lith film test strip of a young boy at the ocean. Incremental exposures are three seconds apart, with normal development in lith developer.

Test strips are required when working with both lith films and Polycontrast printing papers, using the appropriate developer. The following data provides the step-by-step technique for making test strips either for the projected or contacted image:

1. If you are going to make a test strip from a projected image, arrange the enlarger for the degree of enlargement desired and focus the image on the board of the glass-board system as previously described. If the test strip is to be produced from a contacted image, position the enlarger head at its highest point and place the largest empty negative carrier and lens into the proper positions in the enlarger.

2. Stop the lens to the desired opening for test strip exposure; we recommend the $f/16$ stop to begin with. Also, set the repeating

timer for 2 seconds or the interval desired. The 2-second exposure may be changed to adapt it to your own darkroom equipment, after some experience and experiment.

3. Inspect the projected or contacted image to determine the area where the most representative range of tonal values is found; that is, the area containing a variety of blacks, grays and whites.

4. Now, working under the red safelight, place a thin strip of lith film (approximately $1'' \times 5''$) into the selected image area. If the image is to be projected, the film strip should be placed within the defined borders where the full sheet of film would be positioned; if the image is to be contact printed, the negative or positive should be placed over the film strip, somewhere in the center area of the board. Place the glass over the film, allowing the weight of the glass to hold either the single film strip or the contacted pieces.

5. Cover the unexposed test strip with a piece of opaque cardboard, allowing $1/4''$ to $1/2''$ to remain uncovered. Now, with the timer set for 2 seconds, and the lens at $f/16$, expose the uncovered section.

6. At the end of the 2-second exposure, move the piece of cardboard down another $1/4''$ to $1/2''$ and again expose the film. Be certain that the film is not moved or disturbed after the initial exposure, or the results will be inconclusive. Using this process, each step increases the previously exposed step by 2 seconds, thus providing an "additive" exposure technique.

7. Repeat this technique a dozen or so times, so that the total exposure on the first exposed film area comes close to 30 seconds, or whatever time is considered roughly appropriate for a good range of density.

8. After all exposure steps are completed, remove the film from the board and develop in lith developer, using proper time, temperature and agitation techniques, then fix and wash. Be certain to use the same processing techniques which you will use to develop the final image.

9. If properly exposed and developed, the test strip will have definite values from black through dark gray and light gray to white (transparent), in the various exposures at the 2-second intervals. High-contrast test strips will have, of course, a much shorter range of values. Now select the value which you desire and count the number of exposure steps required to obtain that value you have selected. Multiply the counted number of steps by the interval of time for exposure, that is, 2 seconds in this case, to determine the final exposure time.

10. If the density achieved is not satisfactory, increase the exposure time to 3 seconds, increase the number of steps to be given the next strip, or open the aperture to a larger stop, thus allowing more light to pass through the lens.

11. When the final results have been achieved on the test strip, follow the same steps exactly to produce the final image on a full-size sheet of film or paper.

To reiterate, this additive test-strip exposure technique is quite simple and most practical in terms of saved sheets of film and time spent in the darkroom.

Supplementary Darkroom Equipment

You will find, after beginning these darkroom manipulations, that you will need a registration system to provide the accurate, consistent placement of film images in relation to one another. Such a system should not only be accurate, but be inexpensive, simple to set up and use, and should work equally well with **PIN-REGISTRATION SYSTEMS**

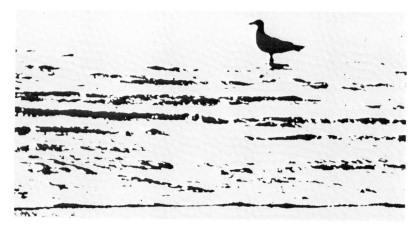

High-contrast image of a seagull.

enlarging or contact printing set-ups. It is important that your selected registration system provide consistency of image placement in total darkness, under safelight conditions as well as in full room light. Such registration will be necessary in the production of line and bas-relief images (Chapter IV), posterizations (Chapter V), for the printing of creative color (Chapter VIII) and possibly for other techniques.

It is important to note that a simple taping of film images so that they flip interchangeably over one another is an acceptable technique for simple registration. This would be completed directly on the contact board where the film would be positioned for exposure, with the film images flipped as desired. If using such a technique, remember that once the film images have been removed from the contact board they are out of register and require re-registration if they are to be used again. Also, it may be difficult in some instances to register on the contact board with material which requires precise placement of image and allows

little margin for deviation. Pin registration does not have these inherent problems.

We use two different types of pin registration in our darkroom manipulations—one used prior to exposure and the other post-exposure—and you will need both at various times when completing many of the darkroom techniques which we describe. Both types utilize exact measure ¼″ plastic or metal registration pins and a metal, hand-held punch, which must make exact ¼″ holes. Both pins and punch are inexpensive and available from

The pre-exposure punching system for film registration. Since film is punched before it is exposed, this procedure must be done under illumination.

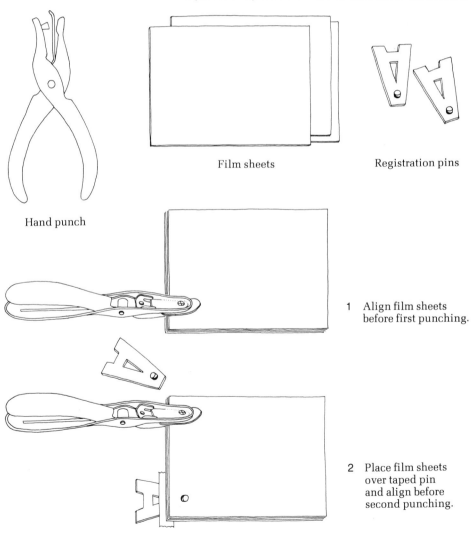

Film sheets

Registration pins

Hand punch

1 Align film sheets before first punching.

2 Place film sheets over taped pin and align before second punching.

any graphic arts supplier. We have found that some types of regular paper punches may be used in place of the graphic arts punch. You will need a minimum of two pins, but we recommend that you purchase two or three pairs for multi-registration purposes. Both the metal and plastic types have exceptionally long life and will be used repeatedly. We recommend a pin base which is rectangular, possibly one inch wide by two inches long, with the mounted pin approximately one-tenth inch in height, or shorter. Most suppliers will have a variety of pin bases and heights from which to choose.

The first type of pin registration which we recommend involves the punching of unexposed sheets of lith film under red safelight conditions, prior to exposure and processing. This technique may not always be used for registration (the tab-pin system, description following, will also be used) but will be most useful when making line conversions (Chapter IV) and posterizations (Chapter V), as well as for other procedures to be described. This pre-exposure punching system is most helpful when an original image is to be used to produce a number of successive images on lith film, all at the same size, but at various exposure levels (as in the posterization technique). The pre-exposure punching technique should be done as follows:

1. Under red safelight conditions, take the number of sheets of film to be used for image production from the box.

2. Jog the film sheets into alignment. Be careful not to touch the film emulsion except at the extreme edges of the film sheets.

3. With all the film sheets jogged together in alignment, punch one hole close to one corner, through all film sheets, with one punching motion.

4. Take one loose registration pin and slip it through the hole in all the sheets, then swivel all film sheets into alignment again.

5. Allowing the film sheets to lie perfectly flat, punch a second hole in an opposite corner of all the film sheets together, with one punching action.

6. Place a second registration pin through the second hole, and check to be certain that there are no buckles in the film. If there are some, remove the second pin and repunch the second hole carefully in another corner, with the film sheets completely flat.

7. Tape the pins to the contacting board of the enlarger in the proper position, and slip the film sheets on and off the pins individually, to make the various exposures.

If you use this pre-exposure punching technique for registration, make certain that once the first exposure has been given to the first film sheet, no movement of image, change of focus or repositioning of the contact board is done, since this will cause alignment difficulties which will negate the registration system. Also, you should plan to use film sheets which are slightly

oversize to make room for the two holes along one edge, or plan to reduce the projected image size slightly so that a margin of perhaps 1/2″ on one side of the film sheets is available. After the holes have been punched in the film, be careful when slipping each sheet on and off the pins, so that the holes do not enlarge or tear, which would also contribute to register problems.

Should you have misregister develop, or wish to register one film image to another after the images have been exposed and

Tab-pin registration. This technique is used with images that have been previously exposed and developed, which later require registration.

Registration pins Film or acetate tabs

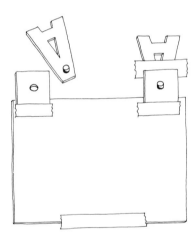

1 Position tabs on first negative or positive and tape pins securely to table.

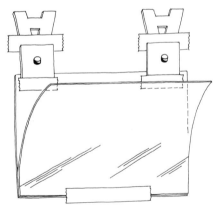

2 Visually register second image to the first. Place second set of tabs over the pins and attach tabs to the film sheet.

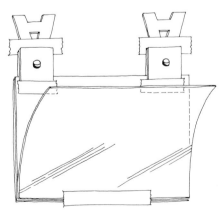

3 With registration of the second film image completed and tabs attached, visually register the third image prior to attachment to a third pair of tabs.

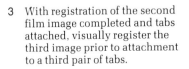

processed, you should make use of our second registration technique, which utilizes scraps of film cut into squares or rectangular shapes with $1/4''$ holes punched in each. This second system is simple to set up and use, and involves two film tabs per negative or positive to be registered, two pins and some transparent tape. A light table (description following) is also helpful, though such registration may be completed without it. The following procedure describes the registration of a lith film negative and positive in exact relationship to one another, and covers the registration of a bas-relief image as described in Chapter IV. Printing on Polycontrast paper of the registered images will then be discussed.

1. Before beginning the actual registration, assemble your materials which include two register pins, four acetate or film register tabs with holes punched, some clear cellophane tape and a film positive and negative, of the same image, in $8'' \times 10''$ size.

2. Tape the two pins approximately $6''$ apart on the table surface or the glass light-table top. Make certain that they are taped securely. Note that the pins must be far enough apart to provide good registration.

3. Lay the film negative to be registered so that one $8''$ side is against the two taped pins and is roughly centered. Now place two of the tabs over the pins, allowing them to overlap the edge of the film negative resting on the table top. When the negative is in the desired position, tape the tabs on the negative securely, on *both* sides of the negative (carefully lifting the tabs and negative from the pins after taping on the first side of the film). The film emulsion of the negative may either be up or down, depending upon the reading of words in the image, or upon the image itself. Actually, emulsion-to-emulsion contacting to the paper print will make little difference in final results. If the assemblage of taped tabs and negative is removed from the pins, the tabs will extend beyond one edge of the negative.

4. Now, replacing the just-registered negative on the pins, repeat the same procedure with the film positive. To do this, place the film positive over the negative and visually position it exactly as desired, out-of-register in this case, to achieve the bas-relief effect. When exact positioning is achieved, carefully tape two corners of the positive lightly to the board to hold it in place. Be certain that the positive is not moved or the desired image effect will be lost.

5. Slip two more acetate or film tabs over the pins, making certain that the edges of the tabs overlap the edge of the film positive.

6. Tape the second pair of tabs securely to the positive, again making certain that both sides are taped. The two pieces of film are now in register with one another and are ready to be printed to Polycontrast paper. (They may also be used to produce a high-

contrast composite film positive on lith film.)

7. Working under amber safelight, tape the tabs, with either film image attached, to the approximate center of the black contact board. Set up the enlarger for contact printing by moving the enlarger head to its highest point, opening the enlarger lens to $f/16$ and setting the timer for 30 seconds, or the desired exposure as determined by test strip.

8. Slide a piece of Polycontrast paper under the film image on the pins and carefully position it. When exactly in place, flip the film image on pins out of the way and tape the paper lightly in

An Italian town was the subject of this bas-relief image. The bas-relief technique is discussed in Chapter IV.

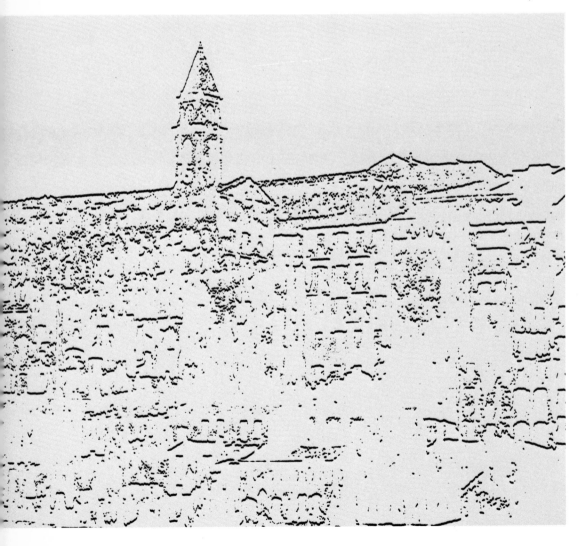

opposite corners. Such taping is very necessary if different film images are to be printed on the paper as with posterizations. In the example presented here, with a film positive and negative producing a bas-relief image, no changing of films will be necessary and taping will not be required. It is a good plan, though, to tape all film or paper sheets when working with pin register to be certain that no movement occurs in the printing procedure. Keep in mind that the glass to be placed over the film/paper arrangement will help both hold it securely in position and prevent curling of the paper.

9. With the Polycontrast paper taped in place, place both the film positive and negative on the pins, then position the glass over the entire arrangement, making certain that the glass exerts firm downward pressure on all parts of the image. If the pins are too high, this will not be possible, in which case one edge of the glass used for contacting should be butted up against the pins. To minimize this problem, it is also possible to purchase very short pins, used only for contact printing, from your graphic arts supplier; however, butting of the glass to the pins will produce excellent results if properly done.

10. Expose the Polycontrast paper for the desired time.

11. If different film negatives or positives were to be printed one over another in an "additive exposure" technique, as with the production of the composite posterized negative (Chapter V), film images would be interchanged between exposures with the pins assuring exact placement of each.

12. Remove the glass, flip the films back away from the paper and carefully remove the tape from the edges of the Polycontrast sheet. Process using normal developing, fixing and washing techniques.

Make certain, when working with pin register and tabs, that all taping, whether it be the tabs to the film or the pins to the baseboard, is secure. Allow for no image movement; otherwise, final images will be blurred.

If you plan on doing considerable work with lith films, and especially work which involves intricate registration such as posterization (Chapter V), a light table will be necessary. There are many kinds and types of light tables available today, all being tables with a glass top and an internal light source transmitting white light through it. It is possible to purchase such equipment through most graphic arts supply houses, but you will find that commercially manufactured light tables are expensive. For that reason, directions for making a light table are included in this book. We have made tables in the manner described, and find them very satisfactory for our purposes. Some mechanical and electrical skills are needed for this project.

MAKING A LIGHT TABLE

To construct a light table, it is best to find an old, small sturdy table, approximately 24″ × 36″ in dimension. The table should be enclosed underneath the top (a table with a single drawer space, approximately 8 inches in depth and allowing for the removal of the drawer is ideal) or be capable of being enclosed with little expense or time. The table top should be wood, an inch thick or thicker, and be capable of being removed entirely from the table in one piece. The size of the table should allow the working area that you want and fit the available floorspace, either inside or outside your darkroom. We have found our light table to be extremely useful in the darkroom, as it provides a secondary white light source and a convenient place for viewing of lith positives and negatives which have just been processed.

Additional items necessary for the light table include fluorescent lights to fit inside the table, a conventional wall switch, about 10 feet of regular lamp cord and a plug, a small quantity of white paint and a piece of $1/4$″ plate glass, smaller than the dimensions of the table top.

Begin by removing the table top and determining the area to be "glassed in." We recommend that you allow at least 3″ of wood around all edges of the table to provide ample support for the glass. Now, using a sabre saw or jig saw, carefully cut out the table top area, using dimensions $3/4$″ *less* than the dimensions of the glass to be used. Thus, if the glass measures 18″ across, the table top cutout would be $17 1/4$″. The reason for this is to allow for a $3/8$″ routed lip around the entire perimeter of the table top opening, $1/4$″ in depth (the thickness of the glass), so that the glass portion will be flush with the top surface when installed.

After completing the cutout, rout the perimeter of the opening to provide the $3/8$″ lip, to a depth of $1/4$″, and check to be certain that the glass will fit easily yet snugly into the routed area. Set the table top and glass aside.

With the table top removed from the table, paint the inside area with a good, flat white paint to provide light reflectance. (If the table has no enclosed drawer area you will need to construct one. This area should be about 8″ deep, light-tight and fully enclosed when the top is secured back in place. The fluorescent light source will be installed in the center of the bottom surface of this enclosed space). After the paint is dry, attach the fluorescent light source to the inside, center portion of the table, where the drawer would normally fit. The light should be in such a position that it shines up through the glass to provide light to the entire glass surface. If the table is exceptionally large, plan to use more than one light. Wire the light to a conventional wall switch, which should be placed in an easily accessible location on the side of the table. Use the cord and plug to supply power from a wall outlet to the switch. Test the light source out to be certain it works

An interesting linear pattern has been created by printing in high-contrast form this photograph of a winter forest.

properly. If there is a front drawer opening cover it with cardboard or masonite.

Now secure the table top to the table using wood screws and insert the glass, after having it made translucent, into the routed grooves. To produce this translucent effect, the least expensive method is to cover the back side of the glass with a thin white bond or tissue paper so that the entire glass area is covered. Another method which may be used is to purchase a sheet of glass which is frosted on one side, from a glass supplier. The working (smooth) side of the glass should be on the top of the table.

You will undoubtedly find that a light table will make a large portion of your darkroom work easier, and provide more working space and a diffused light source. Of course it will also provide excellent working conditions for opaquing and for the pin registration of positives and negatives when doing line conversions and bas-reliefs (Chapter IV), posterizations (Chapter V) and supplementary darkroom techniques (Chapter VI). However, it is not absolutely essential to have a light table if space or funds are limited.

You will find, as we have, that keeping good, accurate records when doing your darkroom experimenting is of utmost importance. Such accurate data will allow you to establish standards for exposure and development for your own darkroom, for your particular equipment, and for your own processing techniques.

A second reason for such record keeping is simply that duplication of an image is possible only if accurate data was recorded during the production of that image; if not, you will not be able to reproduce images exactly, causing wasted time and supplies in experimentation.

A final reason for such recordkeeping is that it allows you to avoid repeating problems which you might have previously experienced and solved, and which might be easily forgotten.

We recommend that you keep your records in a card filing system, or use some type of notebook. In either case, be certain that you have some adequate method of locating data for quick reference by using an index or page tabs. Though such data recording may sometimes appear laborious and time-consuming, you will find that overall results will be consistent and reproducible.

Chapter III, which you are about to begin, presents a number of techniques for producing high-contrast lith images. Most of them will be made using lith film and developer, your darkroom and enlarger. However, you may occasionally desire to have an exceptionally large image produced, beyond the capacity of your own equipment, or you may wish to have a high-contrast image produced by someone else when your darkroom is inaccessible or your enlarger is not operative.

You will find that many local printing shops, which do offset printing and platemaking, will be able to supply you with high-contrast negatives and positives. You should understand that they are normally not in the business of converting continuous-tone images into high-contrast images using the techniques we describe in this book. The materials which they normally work from are set up in a prearranged fashion, such as type on paper and continuous-tone paper prints. Nonetheless, if you explain precisely the results you desire, they should be able to follow your instructions. To do so they will make use of lith film and developers almost exclusively.

You may also find that blueprinting shops as well as graphic display studios will be able to provide you with large photographic prints and, in some instances, with film positives and negatives.

If you do take material for conversion to a printer or offset negative maker, expect the cost to be higher than if you did it using your own darkroom facilities. Also, because such conversions are not a normal part of his work, the printer may not be

fully aware of your desired results, and will not usually allow you to watch as the work is done in his facilities. In all cases be certain to talk with a knowledgeable person at the company as to your desired images, and be sure to obtain a cost estimate for all work to be completed before you place the order.

High-contrast image of a view of Paris from the top of Notre Dame.

This image is a three-tone posterization of shoppers. The posterization technique is discussed thoroughly in Chapter V.

Automobile Image. The three-tone posterization effect pictured here is described in Chapter V.

Impact Through High Contrast

The making of high-contrast images, either negative or positive, is the most important technique to be covered in this book. This is because the high-contrast image is not only an end in itself, but an intermediate step to the making of other types of pictures with more advanced techniques. The high-contrast image which reduces the entire subject to areas of black and white, without intermediate tones of gray, is in itself a powerful tool of expression. But the combination of two, three, or more high-contrast images provides the basis on which more complex pictures can be built, by outlining, posterizing, and other procedures.

The techniques described in this chapter, though, are basically simple both in theory and practice. They involve the use of lith film, a red safelight, your usual enlarger and other darkroom facilities. Information concerning lith films and developers has been given in Chapter II.

Five Techniques for Producing the High-Contrast Image

Probably the most obvious technique for producing the high contrast image is to put high-contrast film, such as lith film or Kodak High Contrast Copy Film, into the camera for the initial exposure. We have experimented with this technique to some degree and have found the results to be satisfactory; however, we do not highly recommend it because of the relative slowness of the film emulsions, the fact that the required developers are not among the more widely used products, and perhaps most important, that the final image produced can only be used in high-contrast form. With conventional films such as Kodak Tri-X and Plus-X Panchromatic films, you can make continuous-tone images which serve two purposes; they can be used as-is, or converted to high-contrast negatives or positives in subsequent procedures.

TECHNIQUE ONE: USING HIGH-CONTRAST FILM IN THE CAMERA

If using lith film in the camera, daylight exposures will be long, thus making the use of a tripod necessary. This is because the emulsion is quite slow with an ASA rating in the vicinity of 10. With lith film in the camera, the light must be bright and the subjects to be photographed must remain motionless during the

Pier at Pismo Beach in high contrast.

lengthy exposures, and should preferably be surrounded by contrasting backgrounds. Since the film is orthochromatic, all red subjects will be recorded as black in the final print.

Another type of high-contrast film, usually available in roll film form through your photographic dealer, is Kodak High Contrast Copy Film. This film is a panchromatic type, thus allowing for good rendition of color in black and white; however, it is intended more for copying and has no rated daylight exposure. Its tungsten ASA rating is 64. High Contrast Copy Film is a type of film which produces good contrast, but preferably from contrasty subject matter.

Development of these films, exposed in the camera, varies from good to unsatisfactory. High Contrast Copy Film calls for development in Kodak D-19 for approximately 6 minutes, which will produce suitable high-contrast results with proper exposures. If you use lith film in the camera, development will be done with

lith developers and the development sequence normally used. It is possible to develop High Contrast Copy Film and lith films with Dektol, D-76 and similar products, but these developers will yield results which are less contrasty than usually desired. Development procedures with developers other than those specified call for trial-and-error methods.

Another technique with which we have experimented involves making the original camera exposures on Tri-X Panchromatic film, with development of the film in lith developer; however, this technique is not recommended as the results produced are much too dense for normal printing exposures, and the contrast produced is not as great as desired.

To summarize, the use of high-contrast films as the original camera record is not a recommended technique. Not only do they require the purchase of less readily available films and developers, but the final subject matter on film will only be capable of being printed and utilized in high-contrast form. The production of a good continuous-tone negative, using Tri-X Panchromatic or similar brands of continuous-tone film, allows for normal photographic exposures and processing, with very consistent results. Further, such film images may easily be converted into high-contrast form in the darkroom, as Techniques Two and Three which follow describe.

TECHNIQUE TWO: ENLARGEMENT OF A CONTINUOUS-TONE NEGATIVE ONTO LITH FILM

This is a valuable technique, which enables almost any continuous-tone image to be converted to high contrast. The original subjects are recorded using conventional black-and-white film, such as Tri-X Panchromatic, and exposed and processed normally. The resultant continuous-tone negatives, in 35mm form, should then be cut into strips containing five to six negatives each, which is usually done for storage. These strips should then be contact printed on a sheet of photographic paper, providing a proof sheet. The proof sheet will allow for viewing of the entire group of images, and will ease the selection of those negatives which you desire to convert into high-contrast form.

At this point, the selected negatives are placed one at a time into the enlarger negative carrier, just as if you intended to print each on photographic paper, and arranged and focused to be projected onto lith film. Thus, the 35mm negative may be enlarged to an 8″ × 10″ image on lith film to produce a high-contrast film positive. Exposure for this conversion depends upon the density of the continuous-tone negative and will be determined by a test strip. A starting point for such an exposure, with a normal incandescent enlarger light source and the enlargement of a 35mm negative to lith film at the 8″ × 10″ size, might be $f/16$ for 30 seconds. Exposure and processing of all orthochromatic lith materials must be done under red safelight.

After the exposure is completed, development of the positive film image should follow in lith developer. If the high-contrast film positive is underexposed you will find that a limited range of tones from the continuous-tone negative appears in the positive and that overdevelopment may be needed to produce an adequate density level. On the other hand, overexposure gives the lith film a greater number of tones and good density will be reached somewhat more quickly than normal. At 68°F., development with lith developer normally should take about 2½ minutes.

After exposure and processing, the high-contrast film positive should be reduced with Farmer's Reducer to remove any unwanted gray areas. After reduction, if intensification is required, chromium intensifier solutions should be used in the proper manner. Finally, any remaining corrections should be made using opaque on the base side of the film positive. Once these manipulations have been carried out, the result is a very high contrast 8″ × 10″ film positive. Now, using the proper procedure, this positive should be printed on a sheet of lith film, thus converting the image to negative form in high contrast. No reduction or intensification should be necessary on this negative if the image was sufficiently contrasty in positive form.

After you have properly processed and dried the film negative, working under the amber safelight, it should be contacted directly to a sheet of Polycontrast printing paper, which is then developed in Dektol 1:1 to produce a high-contrast print. Exposure for this print on photographic paper should be determined by a test strip.

Note in this technique that you have produced both a high-contrast positive and negative on lith film. In the following chapter we will discuss the use of these two films together to produce some interesting images in line and bas-relief forms. Thus, the production of the positive and negative is useful both for experimentation and for further manipulations. Also, the positive may be used in contact with photographic printing paper to produce a negative high-contrast image, if desired.

TECHNIQUE THREE: USING THE "PROOF SHEET" TECHNIQUE

This technique, as with the preceding one, makes use of conventional continuous-tone negatives, properly exposed and processed, then cut into strips containing five or six images when dry. A proof sheet on Polycontrast printing paper may then be made if desired.

To utilize this technique, the enlarger should be set up for a contact exposure, just as in the production of any proof sheet, by moving the enlarger head to its highest point of travel, positioning the largest empty negative carrier in the enlarger, putting in the lens which fully covers that carrier size, and by making certain that the white light from the enlarger covers the entire contacting board. Now, working under red safelight, place a sheet of unex-

High-contrast print of wildflowers.

posed lith film, emulsion side up, on the contacting board and carefully arrange the strips of continuous-tone negatives emulsion side down over the film sheet. Place the contacting glass sheet over this entire arrangement, making certain that the glass does not move the film strips, while at the same time it holds the films in tight emulsion-to-emulsion contact.

When all is in readiness, make the exposure as determined by a test strip or through previous experiments; a good starting point here might be $f/16$ for 30 seconds (150mm lens). Remember that the lighter continuous-tone negatives will require less exposure, while darker negatives will need greater exposure for suitable reproduction.

After making the exposure, carefully remove the continuous-tone film strips from the exposed film sheet, and develop the lith film in lith developer, then fix and wash. At this point you will have an $8'' \times 10''$ sheet of high-contrast film positives which resemble a proof sheet except that film is used instead of paper. With the film still wet, carefully cut the film sheet into individual strips, corresponding to the original strips of continuous-tone negatives.

Example of the proof-sheet technique. Continuous-tone negatives were converted to high contrast by contact printing them on lith film, followed by development in lith developer. Farmer's Reducer was then used to remove unwanted gray areas.

Profile of Gail. Negative high-contrast print.

Profile of Gail. Positive high-contrast print.

Soak the positive film strips for at least 10 minutes in a water bath to soften the emulsion, reduce them with Farmer's Reducer, then intensify if necessary with chromium intensifier. It is important that you watch these small images very carefully when reducing, perhaps with the aid of a magnifying glass for better viewing, so that reduction is not overdone. As they are reduced in strip form, control is much easier than reduction on the entire film sheet at one time. For very critical reduction, you may desire to cut off and reduce only one small positive image at a time, thus providing even greater control over that one positive.

After reduction and intensification have been completed, and the film has been thoroughly dried, the images may be touched up with film opaque under magnification if necessary. Once this is done, the strips of high-contrast positives should be contacted to a second sheet of lith film following normal contacting procedures for high-contrast images as previously described, using test strips to determine exposure time. This contacting step reverses the film

positives, thus producing negative images. Development should be done in lith developer, with proper fixing, washing and drying. At this point you have produced 35mm high-contrast film images in both positive and negative form. After cutting the negative film images into strips resembling the original continuous-tone strips, they may be placed individually into the negative carrier, enlarged to the desired size and printed on photographic paper to produce the high-contrast positive print. If a negative printed image is desired, the high-contrast positive 35mm image is used.

One advantage and one disadvantage must be pointed out here. The advantage is that there will be considerable film saving with the proof-sheet technique as all images are converted to high contrast in smaller film sizes. The major disadvantage, already discussed to some degree, is that opaquing and other manual correction will be more difficult to do in the smaller formats. Such opaquing may be completed later if the film image is to be enlarged to a bigger sheet of lith film which may be needed for photo-silk-screen printing (Chapter VII).

It is also important to note that all continuous-tone negatives to be used in this high-contrast conversion technique on the same piece of lith film should be of approximately the same density, preferably all made at one exposure, and processed together. It is, of course, possible visually to gauge the relative densities of each individual image or strip of images and to try to "gang" negatives of similar density on separate sheets of lith film.

We have found this technique to be very useful when we desire to produce a great many high-contrast renderings during one darkroom session. We recommend that you have a magnifying glass of some type available if working in the smaller formats so that visual inspection of these images is possible.

TECHNIQUE FOUR: PRINTING THE CONTINUOUS-TONE NEGATIVE DIRECTLY TO HIGH-CONTRAST PAPER

We have experimented with a variety of high-contrast photographic papers and have found that, generally, this technique is not suitable for mass production of high-contrast imagery. Our experiments have included the use of Agfa-Gevaert No. 6 (very contrasty) printing papers, as well as a number of high-contrast graphic-arts photomechanical printing papers such as the Kodak Ektamatic and Kodalith Ortho papers.

Using Agfa-Gevaert No. 6 papers, images which are of higher contrast initially, such as a continuous-tone camera negative of a zebra, should produce a high-contrast print with little manipulation. With continuous-tone negatives that have much gray tone or are somewhat low in contrast, the high-contrast conversion with these papers does not produce results which are as contrasty as desired even though the contrast *is* increased to some extent.

We have had better results with graphic arts high-contrast printing papers, designed primarily for photographing originals

High-contrast print of a Morro Bay fishing boat.

such as type matter and halftones. Kodak orthochromatic lith papers, when used with lith developers, provide moderately good image reproduction of the continuous-tone negative in high-contrast form. Also, Kodak Ektamatic "T" paper (designed for automatic machine processing but processed instead with Dektol developer in a tray) yields moderately good results when converting the continuous-tone negative to high-contrast form.

Even if the proper high-contrast relationship is basically established with these printing papers, a major disadvantage is that unwanted gray areas remain on the high-contrast paper and must be removed with Farmer's Reducer. This print reduction is best done with a local reduction technique using a cotton swab on the particular area desired rather than treating the entire paper sheet. If reduction is done over the entire sheet, black areas will also be reduced, thus lowering the contrast.

You will find that Kodak orthochromatic lith papers and Ektamatic "T" paper will produce excellent high-contrast prints when contacted or projected on from high-contrast negatives or positives produced with Techniques Two and Three previously described. These high-contrast papers produce deep black tones and, as reduction was done on the lith film conversion, no unwanted gray areas exist. Keep in mind that such papers are not absolutely necessary to produce beautiful high-contrast render-

ings from lith film conversions. For all high-contrast printing we suggest Polycontrast paper which provides extremely good high-contrast results if exposed and properly processed in Dektol mixed equally with water. Certainly, the versatility of Polycontrast papers for both continuous-tone printing and high-contrast renderings will save you extra expense in the darkroom.



TECHNIQUE FIVE: RUBYLITH AND AMBERLITH MASKING FOR HIGH CONTRAST



This procedure is not actually a photographic high-contrast conversion but more a manual technique used to produce a high-contrast image. Rubylith and Amberlith, both manufactured by the Ulano Company (as well as similar masking materials under different trade names) are basically thin sheets of polyester, coated on one side with a layer of transparent red or amber gelatin. As compared to a photographic high-contrast negative, which is made with a light exposure, manual masking involves careful cutting of the desired image with a sharp knife or razor blade. Rubylith, Amberlith and similar masking films may be purchased in various sizes through your graphic arts supplier. We usually buy it by the 40″ × 50″ sheet rolled into a tube for storage.

As lith materials are orthochromatic, having no sensitivity to red light, Rubylith is intended for use with such materials; Amberlith is designed for use with materials processed under yellow safelight conditions. The masking material itself is not light-sensitive and is used under normal room lighting.

Begin the process by making a continuous-tone print. After processing, take the dry print and tape it on all corners to a flat working surface. Over this photographic print, place a sheet of Rubylith cut from the roll of material, making it larger than the print on all sides by one inch. Before taping it, determine which side of the masking material is the gelatin side by scratching lightly in any corner or along the edge (the emulsion will scratch off), then tape it emulsion side *up* on all four corners, centered over the photographic print. Check to be certain that both the print and the Rubylith are lying as flat as possible on the working surface.

Now take a knife or razor blade and carefully cut through the gelatin coating, making certain that the polyester base support is not cut, using the photographic print as a guide for cutting. A city skyline photograph provides a suitable image for this procedure; cut the Rubylith carefully along the buildings which provide the outline for the skyline scene.

After cutting, the Rubylith gelatin coating should be carefully peeled away from the polyester base support, thus providing a negative or positive in high contrast depending upon which segments have been removed. In the skyline example, if the upper portion or sky area is removed a high-contrast positive image results; if the bottom portions containing the buildings are peeled

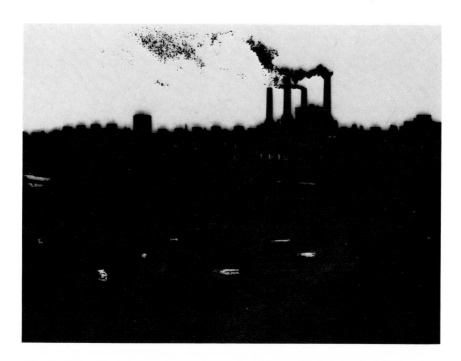

(Above) Industrial skyline scene prior to application of a Rubylith mask. The small white areas in the lower portion of the print are disturbing. (Below) Industrial skyline scene after application of a Rubylith mask to the film positive to make the lower portion a solid black. The resultant film negative (from which the print was made) had clear film areas in the lower portions, thus producing a solid black on the print.

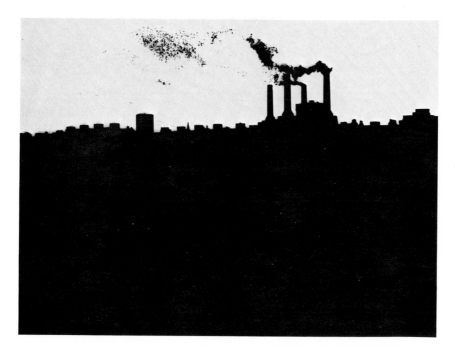

away then a negative image is produced. After removal of gelatin, the polyester support contains only selected image areas (in red) manually traced from the continuous-tone printed image. If mistakes in cutting or peeling are made, correction may be accomplished by placing some of the removed red gelatin material over the area to be corrected.

Under normal circumstances the Rubylith or Amberlith mask may be used for exposure directly to photographic printing paper and need not be converted to lith film form. However, if you desire a lith film rendering for other uses or reversal of tonality, the Rubylith image may be contacted directly to lith film using the usual exposure and processing techniques.

We do not recommend the use of manual masking in place of the high-contrast lith film image except for very simple subjects or in those instances when you intend to drastically alter a high-contrast image. However, you will find that some high-contrast image conversions are possible using such manual masking materials, which cannot be done in the ordinary way. Further discussion will be found in Chapter VI (Supplementary Photographic Techniques) suggesting other applications of mechanical masking devices such as Rubylith. Rubylith may also be used to produce positive images for silk-screen printing as discussed in Chapter VII.

Special High-Contrast Images

USING COLOR SLIDES

As you begin to make high-contrast images in your darkroom, you will undoubtedly be interested in the various other materials available. We have experimented with the use of color slides in the darkroom, in place of black-and-white negatives, and have found the results to be fairly good depending upon the images themselves, the color density of the slides, and the conversion films and techniques which are used.

There are two types of high-contrast films useful for such conversions: orthochromatic lith film and panchromatic lith film. The orthochromatic lith film, previously discussed as the basis for image conversions in high contrast, produces excellent results with images which lack substantial areas of red, as this type of film emulsion is "red blind," recording all red wave lengths as black on the final print. We have used orthochromatic lith film for numerous conversions of color slide material to high-contrast form with little difficulty.

The second type, panchromatic lith film, is used in the graphic arts for color separations using color filters, for later printing colored inks to produce a color reproduction. Panchromatic lith film is sensitive to all wave lengths of light, thus producing a full rendering of color in black-and-white high-contrast form. How-

Mandala (magic circle). Example of a color-slide image converted to high-contrast black and white.

ever, two disadvantages exist with pan lith film. The first is that the use of pan lith film in your darkroom represents an additional expense and its application to other high-contrast procedures is limited. Second, working with pan lith film requires total darkness for exposure and processing.

When using orthochromatic lith film, the selected color slides should contain few areas of solid red or should be used with the understanding that all red areas will reproduce as black does. Begin by carefully removing the color slide from its cardboard mount and placing it into the negative carrier of the enlarger. If working with 35mm color slides, set up the enlarger for the desired enlargement and position the contacting board so that the projected image will fall in the center. Tape or painted guides may be used to mark exactly the desired position of the film to be placed on the board. Set up lith developer, stop and fixing baths, and turn on the red safelight.

Position a piece of lith film in the predetermined location on the contacting board and expose the color slide image on the lith film. Because of the low density of a color slide, exposure is critical and a test strip should be made to determine it accurately. After exposure, process the film normally, thus producing a

high-contrast black-and-white negative of the color slide image. Compare the high-contrast image to the original color slide to decide if the desired results have been obtained. Continue with reduction and intensification if necessary. The high-contrast film negative may be used either in projected form (if made in a size that will fit the enlarger negative carrier) or contact printed on Polycontrast paper to produce a high-contrast print.

If using panchromatic lith film, the initial set-up is the same as with orthochromatic lith film, except that the tape guides on the contacting board must be thick enough to serve as a butting stop for the film. Working in total darkness, with all baths in readiness, remove a sheet of pan lith film from the box and place it emulsion side up against the stops or guides on the board. Expose for the desired time, as determined by a test strip; remove and place it in the lith developer. Under normal conditions, with temperature controlled at 68°F., developing time should be 2½ minutes. A darkroom clock which is visible in total darkness, or has an audible signal, must be used as development time is critical. Also, remember to change your developer frequently, possibly after each film sheet, as depleted developer will require longer development times to produce suitable density and this cannot be determined visually while developing. After development is completed, fix, wash and dry the film, then visually inspect for

Black-and-white photogram of radishes. Photogram image was originally created on lith film so that multiples could be produced. It is also possible to produce photograms on photographic papers.

desired density. If an acceptable negative has been produced, some film reduction or intensification may be done. The negative can then be used to produce the high-contrast print on Polycontrast paper.

In all likelihood you will want to remount your color slide for use in your projector. To do this, you may purchase suitable slide mounts from your photographic dealer. These are very inexpensive and are much better than attempting to salvage the original mount.

Without a doubt one of the most interesting of all the high-contrast creative processes is the making of photograms. This involves the direct placement of objects on the unexposed lith film sheet, with exposure using the enlarger as the white light source. Furthermore, the combination of positioned elements, together with a projected film image, offers unlimited possibilities for creative work.

PRODUCING PHOTOGRAMS

Lith film lends itself to the production of the photogram image because it is easy to work with under red safelight and produces an image of great strength. If the selected object is opaque, such as a human hand, the resultant image on film will be a silhouette of the hand itself; if the element used is translucent, such as a tree leaf, the photogram may contain the veins of the leaf as well as the silhouette. Material should be selected for photograms with these characteristics in mind.

To produce a combination photogram and high-contrast photographic image, the enlarger should be positioned for the degree of enlargement desired, with the selected film negative or positive in the negative carrier. An example here might be the projection of a 35mm continuous-tone or high-contrast negative to 8″ × 10″ lith film. After initial set-up and focusing, the elements of the photogram should be placed over the film positioned on the contacting board in such a way that they combine well with the projected image. This may be determined with the use of a red filter (or a No. 4 Polycontrast filter for a very limited time) so that the projected image may be visually seen on the film but not exposed on the film sheet. Such a red filter may be purchased at any photographic store. With some images random placement of the photogram elements might be used to achieve a serendipitous effect. When all elements are in readiness the projected image is then exposed on the lith film sheet; the objects resting on the film itself will be providing additional silhouette or translucent images. Exposure time may be variable and should be determined by a test strip. The exposed film should then be developed in lith developer, and fixed and washed thoroughly.

Use of the photogram technique will require considerable experimentation to create satisfactory high-contrast images.

Supplementary Information

CONSERVATION OF FILM SUPPLIES Because lith film can account for a large part of your supply costs, it is important to conserve this material whenever possible. To do so, one very good rule to follow is to work as far as possible in the smallest format sizes, thus using less film and saving cost in the darkroom. For example, if your negatives are 35mm or 2¼" × 2¼" in size, convert them to high-contrast form in that size by contacting, reverse their tonality in that smaller size, and in most cases, reduce and intensify them in that size also. The "proof sheet" technique previously described will be of great value in this respect. After all high-contrast conversions have been made,

Example of a midwestern farm scene that has been converted into high-contrast form.

High-contrast print of two Frenchmen with their canine friend. Unnecessary imagery was masked out with Rubylith on the negative.

the final image may be enlarged to lith film or printed on photographic paper depending upon the final results which you desire.

In selected cases where delicate reduction is required, or where negatives and positives require special cropping or opaquing, you may decide to enlarge onto lith film earlier in the process. However, in the long run, remember to keep your high-contrast film images in the smallest form as far as possible, to save supplies and money.

High-contrast print of the Monterey Coast in California.

PRODUCING THE HIGH-CONTRAST PRINT

The production of the high-contrast print is quite simple, either by projection of a high-contrast negative or positive with the enlarger, or by contact printing with a full-size high-contrast film image. For such printing, we recommend the use of Polycontrast papers, with exposure determined by test strip. Development should be in Kodak Dektol, diluted 1:1 with water, followed by proper fixing and washing procedures as in normal printing.

It is possible to purchase high-contrast photographic papers, as discussed in Technique Four of this chapter. Such papers are used in the graphic arts for photographic typesetting and related work, and may be processed with lith developer as well as other developers made especially for use with them. We do not recommend the use of such high-contrast papers because Polycontrast papers can be used for both continuous-tone and high-contrast printing techniques, and produce very acceptable high-contrast results without special treatment.

Remember when printing the high-contrast image that the final print, no matter what type of paper is used, should contain clean, crisp white areas and deep, rich blacks.

Unusual Line Effects

Some exceptionally interesting and different photographic effects can be achieved through the use of line-conversion, bas-relief and Sabattier Effect techniques, which are presented in this chapter. All three procedures are done entirely in the darkroom, utilizing your photographic enlarger, good continuous-tone negatives, lith film and developer.

This high-contrast image of the front of Notre Dame had a wood-texture screen applied during printing.

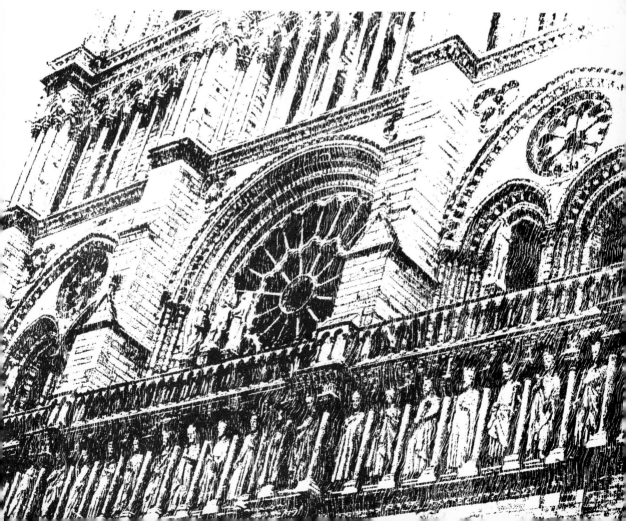

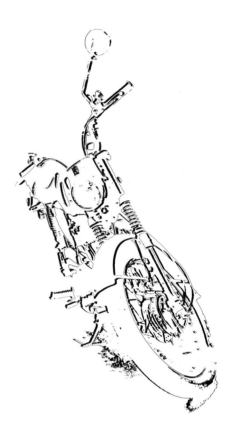

Combination bas-relief and line image of a motorcycle with the background imagery deleted using opaque on the composite negative.

The creation of a "line drawing" photographically results in images which are very different from what a photograph usually looks like. In many instances, viewers cannot believe that the line image is actually a photograph. Such results are quite easily achieved using a high-contrast positive and negative of the same image. An interesting variation of the line-conversion procedure is the production of the bas-relief photograph, which looks like a three-dimensional image. It is sometimes possible to combine line and bas-relief images for an unusual effect.

The Sabattier Effect is a technique used to produce image renderings similar to the line conversion. The Sabattier Effect utilizes certain photographic darkroom procedures including "still" development of the lith film image and a second exposure of the lith film during development.

These techniques are not exceptionally difficult to master; they are, in effect, extensions of the high-contrast technique described in Chapter III. If you have made some high-contrast images as we described in that chapter, you are well along toward mastery of the techniques described in this chapter.

(Left) Window view in Florence. High-contrast print. (Below) Window view in Florence. Line-conversion image made using a registered film positive and negative.

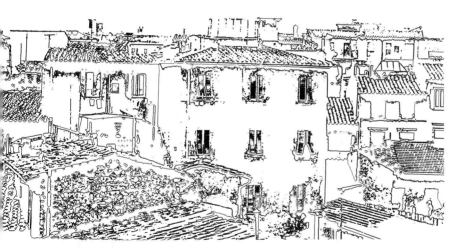

The line-conversion technique is a method of producing photographic images which very much resemble line drawings in pen-and-ink. The production of a line conversion will require the use of a high-contrast film negative and its high-contrast positive, two register pins, four film tabs with holes to match the pin size, some transparent tape, a quantity of unexposed lith film, lith developer and some clear, unscratched acetate. The high-contrast film negative and positive must be exact duplicates with reversed tonality and thus should be contacted directly from one to the other to ensure that the image sizes are alike. (It is desirable to

LINE-CONVERSION TECHNIQUE

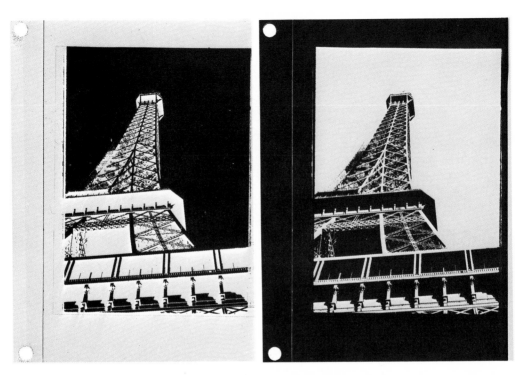

(Left) High-contrast film negative of the Eiffel Tower. (Right) High-contrast film positive of the Eiffel Tower. Both of these film images have been registered using the pre-exposure punching technique described in Chapter II. This ensures accurate registration when doing line conversions.

produce the positive and negative using the pre-exposure registration punching technique as described in Chapter II. If this is done, the manual registration and attachment of tabs described below will not be necessary.)

Begin registration by working at a light table or window, with the dry high-contrast negative resting emulsion side down on the flat surface. Now, using the tab-pin registration technique described in Chapter II, tape two of the punched film tabs securely to one edge of the film negative, then slip these two tabs over the pins. Tape the pins, with the negative attached, to the lighted working surface. The film negative can be removed from the pins by simply slipping it off, yet the pins will remain firmly affixed to the table surface.

On top of this negative place the high-contrast film positive so that the base of the positive is down and touching the base of the negative, with the film emulsion facing you. This "base-to-base" contact of the film pieces should allow the images to be directly superimposed and matching in image direction if, as we have recommended previously, emulsion-to-emulsion contacting was used in their making. Now, using a magnifying glass, place the

Example of the path of light through film, necessary to produce a line conversion.

film positive as nearly as possible into exact register with the film negative on pins, thus completely blocking out light passing through areas that lack density. When the film positive is registered perfectly over the negative, slip two more tabs over the pins and attach them securely to the positive image. Make certain that this taping is completely secure so that the film images will superimpose repeatedly in exactly the same relationship.

Now, working under red safelight, prepare to contact the film negative and positive combination on an unexposed sheet of lith film. Position the unexposed lith film in approximately the center of the contacting board, taping it lightly at opposite corners. Center the film negative and positive images with tabs and pins attached over this sheet of lith film, and tape the pins securely to the contacting board. Thus, the unexposed film is completely covered by both the negative and positive film images. Position the contacting glass over this entire arrangement, or butt the edge of the glass to the pins if using pins which are not short enough to provide good glass-to-film contact. Set the enlarger timer for approximately one-quarter of the time normally used for lith film contacting, say 8 seconds at $f/16$ with a 150mm lens, and check that the lens aperture is set correctly.

Holding the contacting board and glass securely, tilt the board at a 45-degree angle and make an exposure. Repeat this technique with each of the four sides of the board, with approximately a 45-degree angle of tilt and one-quarter of the normal exposure each time. Use the test strip procedure if necessary.

After completing the four-part exposure sequence, develop the exposed lith film in lith developer, then fix and wash. A positive line image is the end result, with the thickness and density of the line determined by the length of exposure and the angle of tilt on each side of the board. This positive line-conversion image can be contacted back to negative form when dry, and the negative can then be used to produce a positive photographic print. If desired,

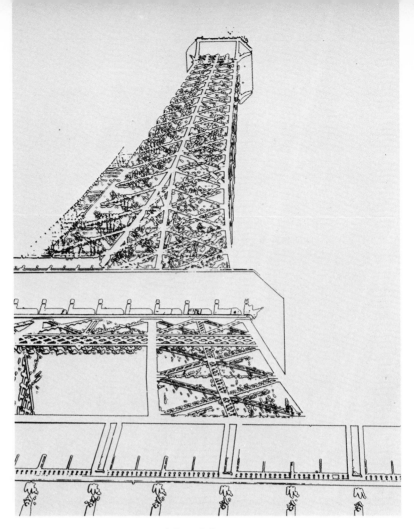

Positive line-conversion print of the Eiffel Tower.

of course, the photographic print could be produced directly (using amber safelight and Polycontrast paper) with the same exposure and tilting procedure. However, we recommend the initial production of the line conversion on lith film so that the making of exact duplicates is possible. Also, the line-conversion film positive can further be used to produce a combination line and bas-relief image, which we will describe later.

In some instances a phonographic turntable may be used to make the line conversion, with a light source such as a flashlight providing exposure from an angle to the side of the turntable. As this procedure entails extra expense and a special darkroom set-up, we do not feel it superior to the one which we have described. Of course, such a system produces an exceptionally even line width over the entire film (or paper) sheet, whereas the manual system as we have described it may produce lines of varying thickness, depending on the angle used for each of the four exposures. This unevenness of line is typical of a freehand

Negative line-conversion print of the Eiffel Tower.

line drawing while the even line is typical of a mechanically-produced image. Depending on the final result you desire, you may find one or the other of the procedures more to your liking.

In the basic set-up of the line-conversion technique which we have described, the actual distance between emulsions of positive and negative is the thickness of the film doubled, usually about 0.008 inches. If a thicker line is desired, it is possible to separate the positive and negative with one or two thicknesses of clear acetate, plastic or polyester. The clear acetate sheets serve to further separate the emulsions, making thicker lines possible.

The bas-relief image has the appearance of scuptural low relief, where forms and figures are distinguished from the surrounding elements by a dark shadow line appearing on one side of the image. This pseudo-three-dimensional effect can enhance certain photographic images and provide an interesting rendition of selected subjects.

PRODUCING THE BAS-RELIEF IMAGE

To produce the bas-relief image, a variation of the line-conversion technique is employed. Instead of placing the high-contrast lith film positive and its negative in exact register with one another, the high-contrast film positive and negative are arranged in a predetermined, out-of-register position. This off-register alignment is best done using the tab-pin registration technique to ensure consistency of placement.

To do this, the negative should first be taped to tabs, which are then slipped onto registration pins. The pins are then taped to the

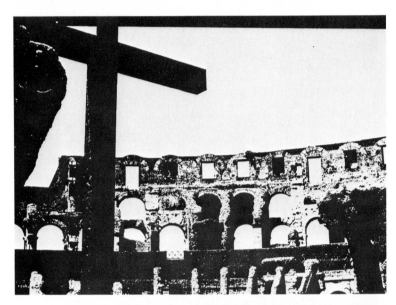

Lith film positive of the Colosseum in Rome.

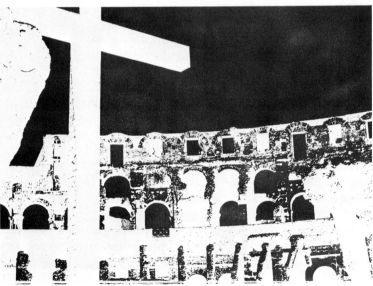

Lith film negative of the Colosseum in Rome.

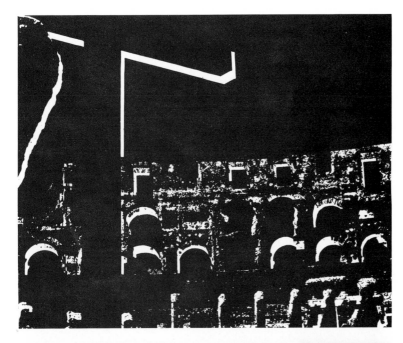

Negative bas-relief version of the Colosseum.

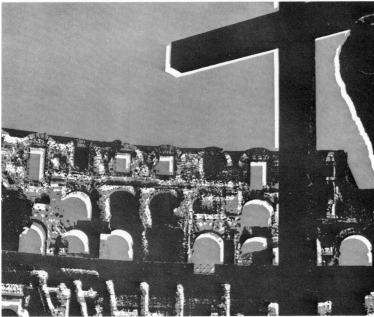

This Colosseum image (reversed) is a combination negative bas-relief (gray printer) with a high-contrast image (black printer) superimposed.

light table surface or window. At this point the positive film image should be placed on top of the negative, with the image facing the same direction, but in a slightly out-of-register position as determined visually. Under normal circumstances a 4″ × 5″ positive will be positioned from ¹/₁₆″–¹/₈″ out-of-alignment with the film

negative, thus allowing light through the off-register areas while both the negative and positive mutually exclude other image areas. When final placement is determined, a second pair of tabs should be used to register the film positive to the negative.

Working under red safelight, the off-register combination of negative and positive should be exposed in contact with a sheet of lith film, using the normal contact film exposure time. After exposure, the film should be developed using the lith development sequence, thus producing a positive bas-relief image on film. When dry, this film positive should be contacted back to negative form and the negative used to produce the final high-contrast bas-relief print by contacting or enlarging on Polycontrast paper.

As with the line-conversion technique, it is possible to produce a photographic print directly from the off-register positive and negative, instead of making the positive and negative film images. You will find, however, that the film positive is useful for production of the bas-relief–line-conversion combination image.

COMBINING BAS-RELIEF AND LINE-CONVERSION

The combination of line-conversion and bas-relief imagery is done using the positive line-conversion image and the positive bas-relief image, each produced using previously described techniques. We have recommended the production of positive film images for both line-conversion and bas-relief procedures, so the materials will be at hand.

To produce the combination of bas-relief and line, position the bas-relief film positive on the light table surface and secure it to a pair of tabs, which are then placed on a set of registration pins. Now, over this film positive, position the line-conversion positive and register it in the position you desire. Then use a second pair of

Lith film high-contrast negative of Millie (left). Lith film high-contrast positive of Millie (right).

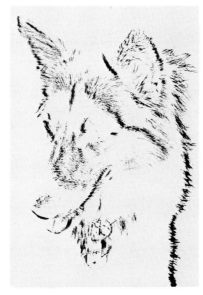

Positive line conversion on lith film of Millie (left). Positive bas-relief image on lith film of Millie (right).

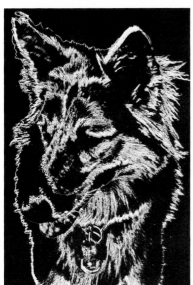

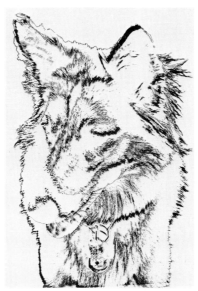

Combination bas-relief and line-negative film image of Millie (left). Combination bas-relief and line-positive film image of Millie (right).

tabs to secure it in register with the bas-relief image. Normally, the images are positioned in exact alignment.

Working under red safelight, contact print the combined film positive sheets on a sheet of unexposed lith film for the usual contact exposure time. This will require a direct white-light exposure from the enlarger. Process the exposed film sheet in lith developer, fix and wash. The resultant high-contrast film negative containing a combination of bas-relief and line images is then used to produce photographic prints by contact or projection printing on Polycontrast paper.

Enlargement of the positive bas-relief and line film image to produce a negative print of Millie.

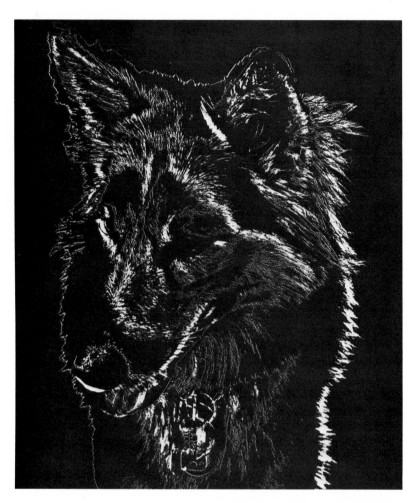

SABATTIER EFFECT WITH HIGH-CONTRAST FILMS AND PAPERS

In the past few years there has been a resurgence of interest in the effects produced by re-exposing films and prints as they develop, using the *solarization* technique and the *Sabattier Effect* technique. Today "solarization" is a term used synonymously with the term "Sabattier Effect"; however, the two techniques are actually different in application and results. Specifically, *solarization* is a technique which produces a true reversal of image through extreme overexposure, so that the negative areas become positive and the positive areas negative. Film solarization in the truest sense of the term is not easily achieved with modern film emulsion structures. Furthermore, the term popularly has come to be used in reference to the re-exposing of a photographic print while developing, thus producing gray tones in those areas of the print which would normally be white. It is in this context that we will later discuss solarization.

High-contrast lith film positive of a radish.

The Sabattier Effect, as a different technique, is a darkroom procedure applicable to high-contrast films and papers, and provides line results similar to, but not exactly the same as, the line-conversion technique described earlier. Instead of producing both a film negative and positive of the same image, putting them in register and exposing them with an angular light technique, the Sabattier Effect procedure produces a line rendering of a photographic high-contrast image through darkroom manipulation.

Sabattier Effect technique with the radish image. Initial exposure was completed to produce a positive radish image (see preceding example). Mackie Lines were then formed around the perimeter areas as a result of re-exposure during development in lith developer.

The Sabattier Effect technique begins with the conversion of a continuous-tone negative image to high contrast using lith film and developer, then reduction and intensification to produce a high-contrast film positive image. Our experiments have shown that the use of a high-contrast film image produces superior results with the Sabattier Effect technique as we will describe it. We have found that the original continuous-tone film image will generally not provide even line renderings on the lith film sheet when used as the original image for this technique. This, of course, is not to say that such continuous-tone negatives will never be suitable; in some instances, especially if the original continuous-tone negative is fairly contrasty, it may serve directly. You may wish to experiment with this once you fully understand the procedure.

After this high-contrast film positive is completely dry and fully opaqued, it will be placed in the negative carrier for projection or used directly in contact with lith film, depending upon the desired image size. Final results, other than size of image, will not be greatly different with either projection or contacting procedures. It is well to note that either a high-contrast positive or a negative may be used for the technique; both will produce line renderings of similar thickness and type, except that the resultant lines will fall on opposite sides of the original image outlines.

Begin the Sabattier Effect technique by making the usual exposure on a sheet of lith film from a projected or contacted high-contrast film image. Once this exposure is completed, re-move the lith film sheet from the contact board and begin development in lith developer, checking the darkroom clock and recording the initial immersion time of the film into the solution. Develop with the film emulsion side up in the tray, and agitate in the normal manner. At the end of approximately one minute, stop all agitation and allow the film to settle to the bottom of the tray, beginning "still" development. This "no agitation" technique will be used for the remainder of the development of the lith film sheet.

After approximately 15 seconds of still development a second exposure is given to the film sheet using any convenient white light source. The time for this re-exposure may vary greatly, anywhere from 1 second or less to 2 minutes, depending upon the results you desire. With a good initial high-contrast film image, and proper enlarger exposure, a 100-watt bulb approximately 6 feet from the developing film sheet may be used for 10 seconds and should provide suitable results. Experimentation will be necessary here.

The re-exposure, as it is given to the film, will have no effect on the areas which are already black, as they will absorb this

additional light with little visible image change; however, after the re-exposure has been given and still development has continued for a short period of time, the previously unexposed areas will begin to turn black. As this occurs, depending upon the variables of the technique, a visible line will appear along the edges of the film image, between the areas of original exposure and the re-exposure. This line, called a *Mackie Line,* is formed by the release of bromide ions from the film emulsion as the silver bromide is reduced to silver by the developer. If there is no agitation, this soluble bromide remains at the image edges, and holds back the effect of the developer at these points, thus forming a line of low density surrounding a heavily exposed area.

Our experience has been that the development time of the lith film sheet, using still development after the re-exposure is completed, may be anywhere from $1^1/_2$ to 3 minutes in length. Thus, total development times may be longer than when developing a normal high-contrast film image (with agitation), and may total 4

High-contrast image of a tree prior to Sabattier Effect treatment.

to 5 minutes in length. Keep in mind that the density of the produced Sabattier Effect negative is important and that development must be of such length to provide suitable density of the re-exposed areas.

After achieving the desired density, the film should be quickly removed from the developer and placed into a fresh short stop bath so that development action is halted immediately. This is necessary so that the Mackie Lines do not overdevelop; the retarding effect of the released bromide ions only lasts for a short time. After the stop bath, the fixing and washing procedures are identical to your normal lith film processing sequence.

Experimentation with the Sabattier Effect technique using high-contrast lith film will provide a wide diversity of image variations, depending upon the control of the variables involved in the technique. One variable is the amount of still-development time before the second exposure is given; the longer the still development before re-exposure the greater the bromide buildup

Positive print of the tree image after Sabattier Effect. Note the Mackie Line formation around branch and root areas.

Negative print of the tree image after the Sabattier Effect procedure.

on the film sheet and the thicker the lines produced. A second variable is the intensity of the light and the time of re-exposure, which should be standardized for controllable results. Finally, variations in the time of agitation development before beginning still development will have a bearing on the final result. Certainly, individual experimentation in your darkroom is necessary to fully exploit the potential results which can be produced with the Sabattier Effect technique.

We have discussed, at this point, the use of the Sabattier Effect technique only with lith films. It may also be used with higher-contrast printing papers, such as the Agfa-Gevaert contrast No. 6, with similar results. The technique works basically the same as with high-contrast films, but results may vary unless precise control is maintained. Thus, it is possible to produce different effects by manipulating the variables even slightly when using the Sabattier Effect with high-contrast papers.

An example of selective solarization with the posterized image. Refer to Chapter VI for information on selective solarization.

SOLARIZING PRINTS

As indicated previously, the term solarization is used most often to describe the procedure of re-exposing a conventional photographic print, after an original exposure to a continuous-tone or high-contrast film image, while development is progressing. This produces the effect of "graying" out the whiter areas of the print. With less contrasty papers, this technique will not produce a Mackie Line and the whiter areas of the print will simply turn gray, while the darker areas of the print remain relatively unchanged.

When solarizing a print, as the white light re-exposure is given to the Polycontrast paper sheet, agitation may continue or be halted, with little if any difference in results. Obviously, print solarization is quite a simple technique with less contrasty papers, and may provide for you another means of expression in printing.

It is possible to use "selective solarization," by covering specific areas during the re-exposure of the print. Prints made with selective solarization usually contain black, gray and white elements in the selected areas. Further information related to "selective solarization" will be given in Chapter VI.

V

Posterization

Posterization is a technique in which a continuous-tone photograph is reproduced by reducing the many tones present to several—usually three to five—distinct shades of gray. This is accomplished by making several different exposure level separations of the original continuous-tone image on sheets of lith film. These separations are then combined by multiple printing to produce the finished posterized photograph.

Some clarification of posterization is necessary so that you may be able to distinguish the various types. The most simple posteri-

Four-tone posterization of Gail.

zation (already discussed at length in Chapter III) is the two-tone posterization. The two-tone effect is simply a black-and-white high-contrast image which contains no intermediate shades of gray. The next type of posterization is the three-tone, which contains both black-and-white areas, like the two-tone, plus one added middle tone of gray. The four-tone posterization has two middle value areas—both light and dark shades of gray are present—as well as black and white in the final posterized print. A five-tone posterization has three gray value areas—light, medium and dark shades—as well as the black and white extremes. To distinguish between the different types of posterizations, one needs to determine the number of separation values.

It is possible to include an unlimited number of values in the posterized image, for example a ten-tone posterization could be produced, yet the posterization effect becomes less as the number of tones increases. Hence, if too many values are present in the posterization, the image will look like a continuous-tone photograph, and lose its different visual appeal. Because of this, there is normally little reason to produce a posterization with any more than four or five tones.

Posterization is done entirely in the darkroom, utilizing lith film and developer and your conventional darkroom equipment. Some previous experience working with lith products (presented in Chapters II and III) is strongly recommended. Also, experience using the techniques of film reduction, lith film contacting and the two types of pin-register alignment (discussed in Chapters II, III and IV) will help achieve good results in your posterization attempts.

In this chapter we will deal only with the production of the black-and-white renditions of the posterized image; however, in both the silk-screen printing technique (Chapter VII) and the color printing procedure (Chapter VIII), we will deal with the production of posterized images in color.

For simplicity, and because the information presented here may be used to produce any number of tonal values in posterizations, we will limit our discussion and data sheets to the production of the four-tone posterized effect. Simple logic will allow you to apply the information to produce the number of tones you desire.

REGISTRATION TECHNIQUES FOR POSTERIZATION The size of enlarger you have available will affect the size of the posterization separations you will be able to produce. If your enlarger has a 35mm or $2^{1}/_{4}'' \times 2^{1}/_{4}''$ maximum negative carrier, it is advisable to produce your separations in the full size you desire and utilize contacting techniques. You can very easily handle the necessary reduction, intensification and manual correction that need to be done in this larger size.

If your enlarger will accommodate the larger formats, such as $2^1/4'' \times 3^1/4''$, $4'' \times 5''$ or bigger, in the negative carrier, it will be desirable and somewhat less expensive to make your separations in these smaller film sizes, and then make the final photographic print by projection. All reduction, intensification and manual correction will be done on the smaller size films.

After deciding on the appropriate film size for your separations, you can begin the posterization technique by completing the pre-exposure registration, or by planning the images to be registered after exposure and processing, using the tab-pin system. As registration of all images is very important in the production of the posterization, each method is discussed briefly as follows (refer to Chapter II for a more detailed description).

Using the pre-exposure punching technique: For this pre-exposure procedure, you must use film slightly larger than the image, to allow for the holes to be punched in the film sheets. Production of the four-tone posterization requires three different separations, so begin this punching technique by removing three sheets of lith film from the box under red safelight, and trimming them if necessary so that they are all approximately the same size. Carefully check to make certain that all film sheets are emulsion side up (or down) and jog them into alignment. Now, along one edge, near a corner, use your hand punch to punch a $1/4$-inch hole through all three film sheets simultaneously. Take a loose register pin and slip all three sheets over the pin, align them and allow them to lie perfectly flat. With the hand punch, make a second hole along the same edge in the opposite corner, with one punching stroke. During exposure two register pins will be taped to the contacting board and each film sheet, before it is exposed, will be placed on the pins. After exposure is completed, it will be carefully removed from the pins and processed.

We prefer this technique when doing posterization separations, as it maintains precision from beginning to end. Remember that once the initial exposure of the first sheet of film has been made, no movement of image, contact board or enlarger may take place or the registration of the images will be inaccurate. If for one reason or another, one of your punched separations is not correctly aligned with the other two, the simplest corrective procedure is to use the tab-pin register system with that film image. Also, if one of the pre-punched sheets is incorrectly exposed and must be redone, the best technique is to expose an unpunched sheet of lith film, then use the tab-pin procedure for registration of that image with the first two film sheets, after processing is complete.

Using the tab-pin registration technique: This procedure calls for the registration of film images after exposure and processing. Usually the film sheets are positioned for exposure on the contacting board using tape or painted guides, so that the image

projected to all three film sheets is in approximately the same place. After exposure, processing, reduction and intensification, the three dry film sheets are ready for registration using the tab-pin technique. This registration is done in a specific and prearranged order, and will be discussed in detail after the production of the separations has been described.

PRODUCING THE POSTERIZATION SEPARATIONS

Making the middle-tone film positive separation: The first step in producing good posterizations involves the making of the middle-tone separation which closely resembles the typical high-contrast image. The middle-tone separation is distinguished from both the light and dark printers because it contains most of the detail contained in the continuous-tone photograph. Begin by producing the middle-tone separation, at a determined exposure time, so that this exposure may serve as a basis for the production of both the light and dark printers. This will help to simplify the technique.

The procedure should begin with the exposure of a test strip of lith film to determine a suitable middle-tone exposure time. This test strip should be placed on the contact board in such a manner that light, intermediate and dark continuous-tone film areas will fall on it. It should be given perhaps 15 2- or 3-second exposures, then processed using normal agitation in lith developer, fixed and

Continuous-tone print of a cat.

DARKROOM GRAPHICS

washed. The step which reproduces most of the middle-tone areas should then be selected. Keep in mind that the relative densities of different continuous-tone negatives will vary and thus the exposure time required to produce the middle-tone separation will differ from one continuous-tone negative to the next. It is helpful to write down aperture settings and exposure times used to produce each separation for later reference. As a starting point, an exposure time of 30 seconds at $f/16$ (150mm lens) may produce a suitable middle-tone image rendering.

After the proper exposure time has been determined, proceed to make the middle-tone separation by correctly positioning an unexposed sheet of lith film (either over the registration pins taped to the contacting board or on the painted guides, depending upon the type of registration procedure used). Expose for the proper time, then develop in lith developer, with agitation, until the proper density is achieved.

Development controls have a bearing on the quality of each of the lith film positives produced. It is important to note here that you should attempt to standardize your development variables—agitation, time and temperature—as much as possible. Normally, when producing the middle-tone separation, development in lith developer, with normal agitation and a temperature of 68°F., should take approximately $2^1/2$ minutes.

Keep in mind that the middle-tone positive separation is most representative of the entire photograph, and should contain roughly equal proportions of black-and-white tones.

Producing the "light" positive separation: With the completion of the middle-tone film positive, the next step is to produce a second positive containing only a few tones of the original. This is not to imply that the density of the film positive is low but that the image recorded on the lith film represents only the very lightest portions of the continuous-tone film negative. To produce this "light" positive separation, exposure is reduced to a minimum, allowing only the very lowest negative densities to print on the lith film.

If the middle-tone separation exposure was $f/16$ for 30 seconds (150mm lens), then a good starting point for exposure of the light printer might be $f/16$ for 5 seconds. There is no exact formula for determination of this exposure time; however, the use of the test strip procedure will help to determine the best time for each image. Remember that the major objective is to record only a few details from the negative on the lith film.

The development of this "underexposed" film image is critical. It is important that development produce good film density, yet with minimum exposure such density is not usually achieved in the normal 2- to 3-minute developing period. We have found that some degree of overdevelopment is usually required to produce

Example of middle-tone film-positive separation with the application of tab-pin registration, as described in Chapter II.

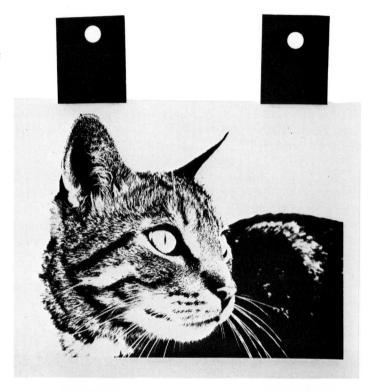

Example of light film-positive separation of the cat with registration tabs attached.

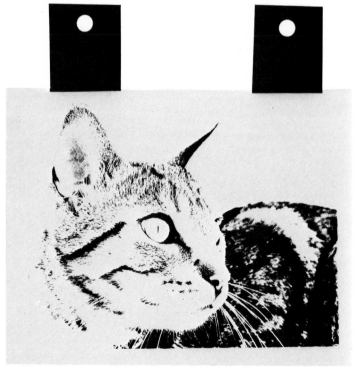

adequate film density. This density is best judged visually while developing, without using time controls, and is not difficult to determine. Nonetheless, it is hard to give a general rule for the time needed for development, as exposure and development time are related. We have had to develop some of our "light" separations for as long as eight minutes to produce a suitable density level on the positive. Lith developers, though not intended for such gross overdevelopment, normally do not produce fog to any appreciable extent if used in such a manner. If such fogging does occur, it can be removed with Farmer's Reducer.

Two factors are important to mention as you develop this minimally exposed film image. Agitation should be moderate to brisk, to encourage greater circulation of developer over the film emulsion. Also, certain continuous-tone areas may begin to appear as you develop, and may not be part of the desired image; however, since their density is usually less than other portions of the image, they can easily be removed in Farmer's Reducer.

Producing the "dark" positive separation: Again working with reference to the middle-tone film image, a final separation containing the greatest amount of detail should be produced. This

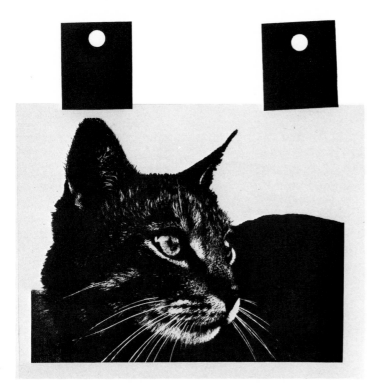

Example of the dark film-positive separation of the cat with registration tabs attached.

positive is not as difficult to produce as the "light" printer, because such an overexposure will develop fairly quickly to suitable density, perhaps in less than the normal $2^{1}/_{2}$-minute developing time. As this film positive contains a great deal of black, the exposure is not as critical as with either the middle-tone or light printers.

If again we assume that the middle-tone positive separation exposure was 30 seconds at $f/16$ (150mm lens), perhaps a good starting point for exposure of this dark printer might be $f/16$ for 60 seconds. As with the light printer, there is no exact rule for determination of the exposure time. Certainly, the use of a test strip for exposure determination is most helpful here.

After exposure, development with normal agitation techniques in lith developer from 1 to 3 minutes will be necessary. Development should produce suitable density in the recorded image areas on the positive, and may best be determined visually while developing, under red safelight. Keep in mind that the positive may be fully developed in a shorter length of time than normal, and that the final film image should be dark, yet still contain a few clear image areas representing the very darkest portions of the continuous-tone negative.

COMPLETING REDUCTION AND INTENSIFICATION

We have now produced three positive film images, each at a different level of exposure and with slightly different development techniques in lith developer. If placed side by side on a light table, each will have a noticeably different amount of recorded detail.

Begin reduction with the middle-tone positive separation, using Farmer's Reducer of normal strength. As reduction occurs, watch for the removal of unwanted gray areas on the film sheet. Be careful not to over-reduce here, and make certain that the final middle-tone positive is exactly as desired when reduction is completed. Repeat the film reduction with both the light and dark separations, doing each individually and carefully.

If necessary, intensify all or any of the film positives with Chromium Intensifier. Normally this step is not necessary unless the film positives were over-reduced or film density was lacking because of underdevelopment. Viewing the results in positive form at this point is an advantage because it is much easier to see what each of the separations will look like in the final print.

Dry the films and complete film opaquing and touchup. Such opaquing may be used instead of intensification if desired, and only a little is needed. Film opaquing may be difficult if the separations were made in the smaller formats.

When these procedures are completed, the three high-contrast film positives are ready to be registered, and then used in register for making the composite posterized negative.

The next step may be the registration of the three film positives to each other using the tab-pin registration system. If, however, you used the preexposure punching sequence described earlier, you will not need to do such registration at this point. Even so, you may wish to recheck register by placing the separations on pins and viewing them carefully.

Begin with the dark separation and place it so that the image faces in the desired direction (signs or words will dictate this direction if any are to be included in the final picture). Using two film tabs and transparent tape, secure the tabs along one edge of the film sheet, then slip these two tabs onto the taped registration pins. Now visually align the middle-tone separation to the dark film image and, when in exact alignment, slip a second pair of tabs over the pins and tape them securely to the middle-tone film. With both the dark and middle-tone separations on pins, repeat this procedure exactly for the light film image using a third pair of tabs.

A light table will be helpful in this alignment and registration process, as will an overhead incandescent light in most instances. Also, a magnifying glass will help in the exact alignment process. Be sure that the light separation areas fall in the center of the middle-tone image areas, and that the middle-tone areas center over the dark separation areas.

When completed, check the films to be sure they do not buckle as they lie on the flat surface. If they do, retape the tabs to correct this. Check also to be sure that exact superimposition is retained as these images are slipped on and off the pins.

Begin by setting up the enlarger for contact printing as described in previous chapters. When preparing the developer, instead of using lith developer, use Dektol developer mixed one part Dektol to five parts of water. This highly diluted solution will slow development, thus allowing for the good, even tonal separations necessary in the composite posterized negative. All other chemistry will be the same as with normal lith film processing.

Tape the register pins to the contact board with the three film positives still attached, then remove the film sheets carefully from the pins and lay them aside. Working under red safelight, remove a sheet of lith film from the box, cut it slightly larger than the film positives and tape it lightly to the contacting board. Place it emulsion side up, in the exact area where the film positive images will fall when placed on the pins. This taping is necessary to hold the unexposed film sheet securely so that no movement occurs during the various steps of the multiple-exposure sequence.

The exact sequence of exposure of the three film positives on the film must be followed. The posterized effect will not be produced if this is not done. The exposure technique to be used is

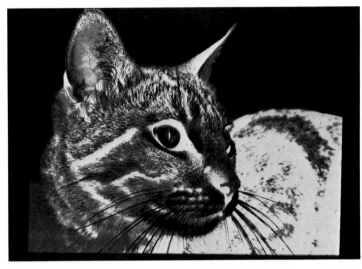

Composite posterized negative of the cat image on lith film.

"additive" in nature, thus each film positive enables light to be added in certain areas. Exposure must be as follows:

First exposure: lightest film positive (least amount of detail)

Second exposure: middle-tone film positive (middle amount of detail)

Third exposure: darkest film positive (largest amount of detail)

The time of exposure will vary in relation to the separations and the desired results. Application of the test strip procedure is essential for exact determination of exposure times. We have found that a good starting point, with a 150mm lens stopped to $f/32$, is a 2-second exposure for the lightest film positive, followed by a 2-second exposure with the middle-tone separation (making a total of 4 seconds for the open areas found in both positives), and finally a 40-second exposure for the darkest film positive. Thus, the open film areas in all three separations will receive a total of 44 seconds of exposure. The longest exposed areas will become the darkest portions of the composite negative.

With the completion of this triple exposure sequence, the lith film sheet (or test strip) should be carefully removed from the contact board, making certain the tape is removed from the exposed film sheet before development. Place the lith film in the dilute Dektol solution and develop with agitation. Development time at 68°F. with normal agitation is generally from 1 to $2^{1}/_2$ minutes. The light gray and middle gray areas must be allowed to develop fully, along with complete development of the darkest film areas. Normally the image is completely visible after 30 seconds or less of development.

When development is completed, the different tones of the posterization are clearly visible on the lith film. Even if the

composite negative does not appear as you desire it on the film, we have found that it is best to make a test print from the composite on Polycontrast printing paper before discarding it, so that the actual printed image can be viewed. If the tonal steps of the printed image are not distinct enough for you, the exposures in the composite posterized negative are probably incorrect. This will entail redoing the composite negative in exactly the same printing sequence, but using increased or decreased exposures in one or more steps.

It is possible to produce the posterized print without making the composite negative. This requires contacting or projection of each positive separation to negative form on lith film, then development in lith developer, and finally pin registration of the negatives to one another as we have described. The negative high-contrast separations are then contact printed directly on Polycontrast paper, exposing the light, middle-tone, then dark printer in the same sequence as in the making of the composite posterized negative. The print is then developed in Dektol diluted one part to two parts of water. We do not recommend this procedure because it requires extra sheets of lith film to change the separation positives to negatives. Also, the negative high-contrast separations may only be used for contact printing, because registration of each printer in the negative carrier for projection printing is nearly impossible. However, you may wish to experiment with this procedure in your darkroom.

Depending upon the size of the composite negative, it may now be used either in contact printing with Polycontrast paper (for a same-size image), or if small enough to fit in your enlarger negative carrier, printed onto Polycontrast paper to whatever size is desired.

PRODUCING THE POSTERIZED PRINT

The test strip is a valuable tool for determining the exact exposure time for the final print. We have found that a good starting point for exposure with an average composite posterized negative in contact with Polycontrast paper will be approximately 20 seconds at $f/16$ (150mm lens). If the negative is darker than average the exposure time will be longer, and if the negative is lighter, the exposure time will be shorter.

After exposure the print should be developed in Dektol, diluted one part to two parts water, for from 1 to $2^{1}/_{2}$ minutes. Agitation should be continuous throughout development. The developer may be diluted more than the indicated 1:2 dilution to produce more even tones in the gray areas. This generally requires an increase in development time. After development, the print should be fixed and washed as usual.

The final print of the four-tone posterization should contain crisp white and deep black areas, along with both light and dark

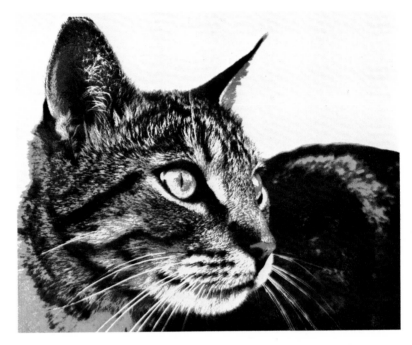

Four-tone posterization of the cat.

Two-tone posterization of the cat, derived from middle-tone separation.

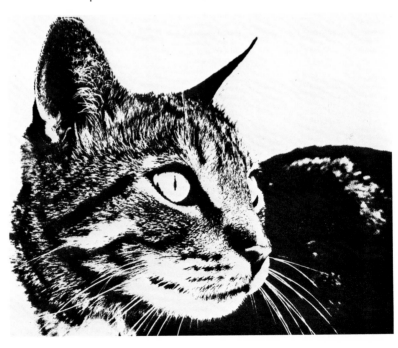

DARKROOM GRAPHICS

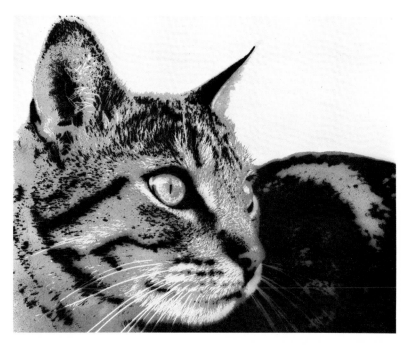

Three-tone posterization of the cat, derived from dark and light separations.

Three-tone posterization of the cat, derived from the dark and middle-tone separations.

Four-tone posterization of a Morro Bay Scene.

gray intermediate shades. If you find that the differences between white and light gray, light gray and dark gray, or dark gray and black are not pronounced enough, production of a new composite posterized negative will be necessary. The remade composite negative should be made with different exposures for some (or all) of the three separation positives. Occasionally a composite negative which appears to have satisfactory tone separation will not produce a print of equal quality. This may also necessitate the making of a new composite negative.

Sometimes, when we are not sure whether our initial separation positives will produce the results we desire, we may make a number of different positives, perhaps five or six in all. Then, depending upon the results we desire with the particular image, we explore the many possibilities of using different separations in combination to produce varying tones.

Supplementary Techniques for Special Effects

VI

The purpose of this chapter is to provide you with some auxiliary techniques which may not by themselves produce finished imagery, but which are used to enhance visual impact. This is not to say that certain of these techniques do not produce images in their own right, but that in general they would be used in combination with the other procedures described in this book.

You will find that some of the supplies are not often used in photography. In some cases these products are those used in the graphic arts, while in other cases the products may be often used by artists. We have attempted to specify the products with which we have had the best results. Remember, however, that such recommendations do not imply that other products will not work equally well.

Keep in mind as you read this chapter and follow the techniques—experimentation is the key. When a technique is employed in a way which has not been tried before, you may fail. If you do fail, you will more fully understand the drawbacks of the procedure. If you are successful, your images should benefit by this creative exploration.

Sooner or later you will want to combine several images into one print. Of course, the most obvious way to accomplish this is to do it entirely in the camera, by double-exposure. This requires considerable skill and visualization of the combined images, as well as a certain amount of luck in taking the multiple photographs themselves. Many times the picture does not come out exactly as visualized, and it is not possible to repeat the original photographic set-up. For this reason, we include six methods for producing multiple images from either continuous-tone or high-contrast originals, using darkroom techniques in place of direct camera exposure. As you will note, the procedures are not particularly complex and may be interchanged or combined depending upon the desired results.

MULTIPLE-IMAGE TECHNIQUE

Sandwiching: This procedure involves the placing of two or more film images in the negative carrier. If continuous-tone film images are combined, they should be thin so that a reasonable

This combined image of Gail is an example of multiple image production using the in-camera double-exposure technique.

Two separate images of man and dog on the beach were combined to create this composite image.

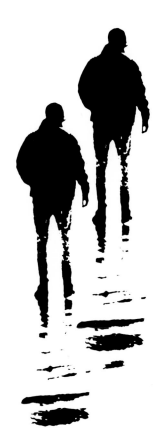

The illusion of movement—the man walking—was created by repositioning the easel between exposures.

amount of light can pass through them. With high-contrast film images, it is best to work with film positives, thus allowing greater transmission of light through the film. Also, with both high-contrast and continuous-tone film positives, the best procedure is to project the combination on a sheet of film, then use the developed film negative containing the multiple imagery to produce the final print, by contact or projection.

Contact board movement: This method is easily accomplished. Initially the enlarger is set up for projection of a negative that contains subject matter suitable for repetition in the final print. Exposure time for the film or paper to be used is then determined. Then the film or paper is positioned on the contact board and the first exposure made. At the end of the exposure, the contact board is moved to another position, and a second exposure is made. As many additional exposures as desired may be added. Image placement can be at random or pre-determined with a guide set-up.

This technique may be varied by enlarging or reducing the image between movements of the contact board, thus causing the images to appear to recede. Another variation is to change the exposure times for each of the movements so that images are recorded in different densities.

Image reversal: This procedure is also quite simple and involves the direct reversal of a film negative or positive in contact or projection, so that the images appear to be overlapping one another or criss-crossing each other. Such an effect merely involves the flipping of the film negative in the negative carrier or on the contact board to achieve the mirror-image result. Interest is generally focused toward the center of the picture by the nature of the technique.

Symmetry of image: Somewhat related to the image-reversal procedure, this method involves the making of two identical images. After they are completely dry, they should each be cut in half. Then one of the two mirror-image halves is butted directly against the other, one half reversed to provide the symmetry effect. If the cuts are exact, perfect symmetry will be achieved. The taped negative (or positive) is then exposed by contact or projection to produce a symmetrical image on film. This composite is then used to make the final print after any necessary opaquing.

Rotation: The use of rotation between exposures produces a circular symmetrical effect. The procedure involves the rotation of the contact board or paper easel on a thumbtack which has been taped to the baseboard of the enlarger with masking tape, so that the upward-facing tack point serves as a pivot. A common household "lazy susan" which turns a full 360 degrees may be used if available.

The technique simply involves the taping of the photographic paper or film sheet to the contact board which rests on the thumbtack point or the lazy susan. The image is then projected on the paper or film sheet while the board or lazy susan is rotated in steps or continuously through the exposure. If a constant exposure is provided, then timing is necessary so that equal intervals (and densities) of the image will result; if the image is exposed with an interval timer which shuts off after each exposure, no other timing unit is necessary. If exact symmetry is desired, some planning will be necessary for the determination of specific stopping points. Marks may be made on the lazy susan for this purpose.

Paper sketch: This procedure can be used to produce a composite image on film or paper from a multitude of different image sources. Many different continuous-tone images, or high-contrast images, or combinations of both may be combined with little difficulty and some planning. As an example, consider the combining of two different high-contrast negative images that you might want to align perfectly in the exact center of the final print. The method is as follows:

1. Position the negative to be exposed on the upper portion of the paper sheet in the negative carrier, and place the negative carrier in the enlarger. Project the image on the baseboard and

focus it. Mark on the contact board with masking tape exactly the position of the photographic paper.

2. Take a piece of paper exactly the same size as the photographic printing paper to be used, place it against the taped guides on the contact board and project the image in the negative carrier to the top half of the paper sheet. Mark with a pencil on this paper the outlines of the image, especially the points where the two images will blend in the center of the sheet. Turn off the enlarger light and place the penciled paper sheet aside.

3. Working under safelight conditions, remove a sheet of print paper from the box and position it against the guides on the contacting board. Cover the paper with the contacting glass and expose the top-half image for the desired time. (Some amount of dodging to soften the areas where the images will meet may be necessary.)

4. After the exposure has been completed, remove the first negative from the negative carrier and position the second negative in its place. Use the red filter in the enlarger filter holder, and without lifting the glass, cover the once-exposed photographic

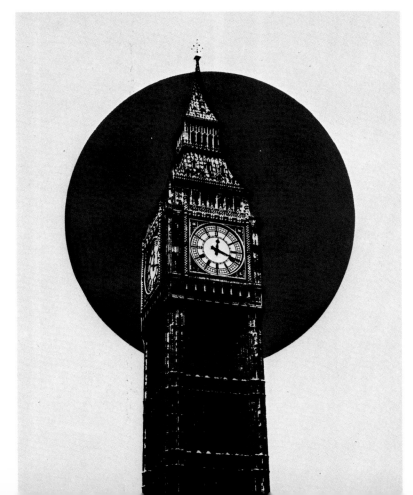

This high-contrast image of Big Ben was combined with the sun image by using a separate mask. Registration of the mask with the image was completed using a paper sketch.

paper sheet on the contact board with the penciled paper sheet, exactly aligning the two. Turn on the enlarger light so that the bottom half-image is visible on the penciled paper sheet, and align the marked points and the projected image together by moving the whole contact board arrangement. (The red filter prevents the paper from being exposed while you are aligning the images.)

5. After the exact position has been determined for the second image, turn off the enlarger light, remove the penciled paper sheet from the contact board surface and remove the red filter. Expose the bottom half-image for the desired time. (Again, if necessary, dodge the blending area of the two images to soften the appearance.)

6. At the end of the second exposure, process the film or paper sheet in the normal way, wash and dry. (See page 83 for an image made by this method.)

The paper guide technique is useful and adaptable for combinations of as many photographic images as desired. Of course, the paper guide sheet must be used for positioning each of the images in relation to the previous ones before exposure. Keep in mind that the marking of strategic meeting points of each image is essential for proper register.

USING TRANSFER LETTERING WITH FILM IMAGES

The combination of transfer letters with photographic images is quite easily done. Many brands of transfer (or "press-on") letters are sold at art and hobby stores. Check that the letters are a dense black, and that they can be transferred easily to paper or acetate.

You may prefer to use the letters directly on a film positive that already contains desired photographic images. In that case, simply make your film positive, dry it thoroughly, and transfer the desired letters directly to the film. Most brands of transfer and press-on letters will adhere securely to acetate, polyester and plastic film bases. When transferring the letters to the film positive, place a piece of white ruled paper behind the positive film as a guide for alignment.

Another procedure you may prefer is to transfer the letters to a sheet of clear acetate, polyester or plastic and then contact print that on lith film, thus making a negative of the letter images. These words or letters may then be cut out of the negative and inserted into a negative containing photographic images. The cutting necessary here is somewhat more difficult and requires the use of lith tape (red cellophane tape) to cover all of the cut joints so that no lines will be produced in the final positive print.

A third technique is to transfer the letters to acetate, polyester or plastic, and then to tape the sheet holding the letters to the positive film image. The positive would then be contact printed to negative form, where the tape and lines from the acetate sheet can be opaqued out. This technique allows your positive film image to

remain available for other uses which will not require such type matter, as the type sheet may be easily removed from the film positive. In addition, the type matter may be used again with other images.

You may obtain acetate, polyester or plastic sheeting at most hobby, art and photographic stores. It is also possible to place unexposed sheets of film into the fixing bath, thus clearing them and making them suitable for transfer lettering after they have been fully dried. This procedure is expensive and is not recommended unless necessary.

The primary purpose of a masking system is to selectively block out or add details to a print. Masks can be made from many materials, including paper and special masking films. Remember that all photographic films are masks, and differ from other masking products only in that the images are produced by light instead of by hand.

MASKING SYSTEMS

The simplest mask is the paper cut-out. We have tried many kinds of paper and have found that the black paper used for packing film and other photographic materials works well. Occasionally dense white cardboard or mat board is preferred when marking or writing on the mask is necessary. Whatever paper is selected, it must be opaque.

Begin the paper masking technique by determining whether the mask will be used in conjunction with the projected image on the contact board (with film or paper) or placed in the negative carrier. Also, you must determine whether the mask is to add or take away image areas which will appear on the particular positive or negative image. In any case, you should carefully cut the mask to the predetermined size by using the original image as your pattern. Be certain that the cutting procedure yields sharp, clean edges. If you are preparing a mask to be used with an image to be greatly enlarged, remember that accuracy when cutting is critical since minute flaws will be enlarged along with the image.

Instead of cardboard or paper, it is possible to use an exposed, processed and dried print (of the original image) which has been cut to the specific masking pattern desired. When using the photographic print, you will find that double-weight papers will be better than single-weight papers, due to their additional thickness and opacity. The major disadvantage of cutting a print to form a mask is that the print itself is destroyed in the process. However, the photographic image paper mask can be extremely accurate because you have the original image to follow for cutting.

Thus far we have been discussing fairly elementary materials in the making of a mask. As indicated in Chapter III, specific products are manufactured for masking which are in some cases superior to the paper or cardboard types. Ulano Rubylith and

Amberlith, available from most graphic arts suppliers, are two such masking products; there are other similar masking films on the market. Such mechanical masking materials are superior to the more readily available and inexpensive paper and cardboard masks. They can be cut to more complex shapes, and when cut small and used as "floating elements" (unconnected segments of masking material in a design), they are easier to handle.

As stated in Chapter III, such films are transparent red or amber gelatin, coated on a flexible polyester support. The image to be masked is placed directly under the transparent masking material and a knife or razor blade is used to cut the thin gelatin coating around the desired areas. After cutting, these gelatin areas are peeled away, leaving only clear base, while the remaining areas provide the mask. This may then be used either in projection (with a negative, a positive or by itself in the negative carrier) or in contact with film or paper to serve the desired masking purpose. Red masking materials are generally used for products (such as lith films) which can be handled in red safelight conditions, while the amber masking materials are made for products (such as enlarging papers) which may be handled under yellow safelight conditions.

One other type of masking system is occasionally used in the toning or coloring of prints. This system involves the painting of a type of rubber cement onto selected areas of the dry print, thus protecting the covered areas from the toning and coloring solutions. We have used the Grumbacher Company's Miskit successfully in this procedure. Make certain that the image area is fully covered with the rubber cement material before you begin toning or coloring—if pinholes exist they may cause problems. After the coloring or toning procedures are completed and fully dry, gently rub the Miskit off the surface of the print.

SELECTIVE SOLARIZATION OF PRINTS

When making your final high-contrast prints, you may occasionally want to employ the solarization techniques for graying down selected areas. The actual solarization technique (discussed in Chapter IV) involves the exposure of a developing print to white light, thus producing gray in all areas that normally would have been white in the print. There will be times when you may not want to solarize the entire print, but only a segment or portion. Thus, the "selective solarization" technique should be employed to mask out those areas which you do not want re-exposed.

To do this, begin by cutting a piece of opaque paper or cardboard to serve as a mask for the photograph. This may easily be done by tracing the image with pencil while it is projected on an opaque piece of paper or cardboard placed on the enlarger easel. The image should be cut accurately along the traced lines, then placed near the developing tray for use during the develop-

ment procedure. The photographic print should then be exposed for the desired time under darkroom safelight conditions.

After the print has been exposed, development should be begun in the normal manner. As the image becomes visible in the developer, it should be quickly removed and positioned on a flat counter surface next to the developing tray. (It may be rinsed briefly in a water bath just prior to this, to slow development.) After it has been positioned on the flat surface and smoothed out, the paper mask should be aligned on the wet paper sheet in relation to the visible image areas. The positioning of the mask and image should be exact. Now the white room lights should be turned on for one or two seconds, thus solarizing the print. This exposure will affect only the white uncovered areas of the print and will have little effect on those areas already black or those areas protected with the paper mask.

After exposure, and again working under safelight, the paper mask should be removed from the surface of the print and the print re-immersed in the developer until the final results are obtained. After development is completed, the remaining processing procedure is identical to that used for other prints. It has been our experience that the paper mask will last two to four prints, after which it will begin to deteriorate and should be replaced.

USING A PROCESSED PRINT TO MAKE PAPER NEGATIVES

For a quick reversal of an image, a processed print can be used to make a paper negative. Basically the procedure utilizes a thoroughly washed, still wet print placed in contact with an unexposed sheet of photographic paper. The sandwiched materials are exposed to room light for a predetermined time, followed by development in the usual paper developer. If a positive print is used in contact with the printing paper, a negative is the result; if a negative print is contact printed on a sheet of paper, a positive print results. With controlled exposure conditions, the results using such a printing technique can be quite satisfactory. The procedure for making a paper negative is as follows:

1. Expose a high-contrast or continuous-tone print in the normal manner. Develop, fix and wash the print thoroughly.

2. After the print has been thoroughly washed, position it so that you may view the image lying face up in the water bath tray. Also, prepare a clean, flat working surface such as the back of a photographic tray, a piece of glass or a smooth counter top.

3. Under amber safelight, take an unexposed sheet of photographic paper from the box and lay it emulsion side up on the smooth surface. Position the photographic print, from the water bath, face down (emulsion-to-emulsion) on top of the unexposed paper sheet.

4. Using a roller or squeegee, smooth the two sheets together to ensure good contact between them and to remove all air pockets.

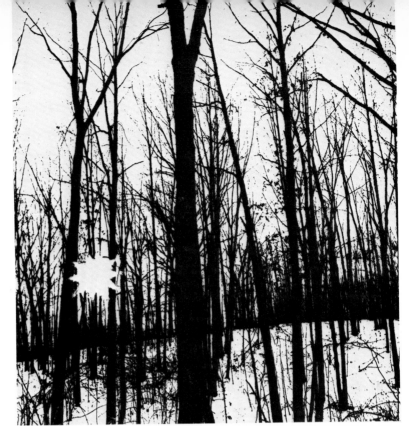

Original high-contrast print of the forest scene.

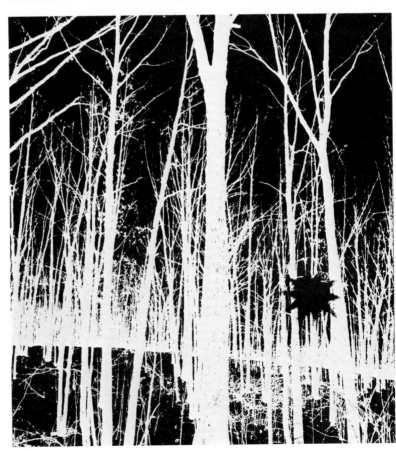

This negative version of the forest image was created by using the original high-contrast image previously shown as a paper negative.

5. Using the normal darkroom white-light source, expose the paper. A 100-watt incandescent bulb approximately 6 feet from the paper may require an exposure of from 5 to 10 seconds. Remember that the thickness of the paper carrying the photographic image will have a bearing on the exposure time, as will the density of the print.

6. After the exposure has been made, the two sheets must be separated from one another and the exposed one processed in the usual manner. An image with exactly opposite tonality will be the result.

An interesting variation of this procedure may also be utilized. After the paper has been exposed for the first time (step 5), the two sheets should be separated from one another. However, instead of beginning development immediately, the original print should be turned over so that the image is now facing upward, instead of toward the undeveloped paper sheet. The prints should again be contacted securely with the roller or squeegee, then a second exposure is given. After the second exposure, the sheets are again separated and the twice-exposed print developed. The image

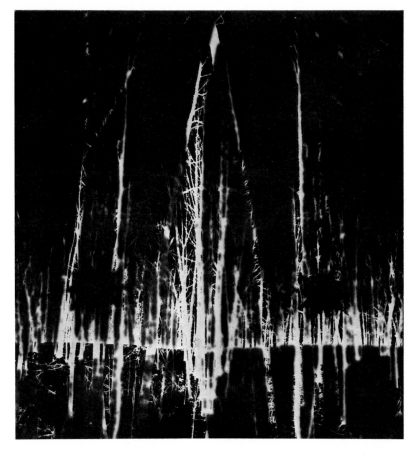

This ghost-like image was created through the adaptation of the paper-negative reversal technique and employs a double re-exposure.

produced may be symmetrical in nature, but the thickness of the paper will cause the second image rendering to be lighter and somewhat faded looking, thus producing a "ghost effect."

Since two exposures are given to the paper, it may be necessary to cut down one or both of the exposure times so that the result is clear and distinguishable. Even a slight overexposure may cause much image loss with this technique. The double-exposure procedure can often result in chaos, yet in some instances when the basic image was fairly uncomplicated, it might well be used.


USING
FLASHING AND
PAPER
NEGATIVE
TECHNIQUES
IN
COMBINATION


By adding to the procedures involved in the paper negative techniques, you can make a composite image which contains some unchanged detail along with a partially flashed image producing a "ghost effect." For this procedure it is best to begin with a fairly simple image as this technique makes even simple images much more complex. For the purpose of clarity, we will discuss the production of a specific image—that of a tree with both branch and root structures visible, and with no background detail. The procedure would be carried out as follows:




1. Place the negative of the tree into the negative carrier and project it on the contact board so that it will be centered within the 8″ × 10″ print area.

2. Working under amber light, print the image on a sheet of Polycontrast paper, in 8″ × 10″ size, marking the section you wish to solarize. This marking is most easily made with tape on the contact board under safelight conditions. In this example, the tape guides would be placed in the center of the print, as we have decided to reverse the root area while leaving the top portion of the tree branches unchanged.

3. After exposure, take a piece of cardboard or mat board and cover the area of the print which will be flashed using the tape markers for placement of the cardboard. After covering the area (the root area in our example) turn on the normal darkroom white lights to expose the uncovered portion of the paper for five to ten seconds. In our example the top area of the tree was uncovered and thus has been exposed; it will become black upon development producing a total loss of image.

4. At the end of the room-light exposure, develop the print using normal processing procedures, then fix and wash it thoroughly. The print should have a good visible image in the root structure area, while the top half of the sheet, normally containing the branches of the tree, will be totally black. We will call this positive an "intermediate print" as it will be used in the production of the final print.

5. Leave the intermediate print in the water bath, and under amber safelight take another sheet of photographic paper from the box. Position it on the contact board of the enlarger and expose it

normally to the tree image, in the same manner as with the original exposure of the intermediate print. Make sure that no movement of the contact board or film image has occurred.

6. Take the exposed but undeveloped print and place it emulsion up on the back of a photographic tray, piece of glass or counter top. Now remove the intermediate print from the water bath and position it so that its image faces up, with its base in contact with the exposed paper print lying on the flat surface. The images need not align perfectly (this would be very hard to do anyway) and in fact a certain amount of image offset is desirable to create the "ghost effect." However, the branch areas should be on top of branch areas and root areas over root areas. Use a roller or squeegee to ensure good contact between the two sheets.

7. After the sheets have been sandwiched in contact, emulsion-to-base, the normal white light of the darkroom should be turned on for about 2 seconds. Thus, the area that was black in the intermediate print will hold back light and leave that area in the exposed but undeveloped print unaffected; but the area in the intermediate print which has the root structure will be exposed to the paper sheet and produce a negative image. In addition to this negative effect, a white "ghost" image will appear in the areas where the tree was out-of-register in the intermediate print.

8. After the brief white-light exposure is completed, separate the two pieces of paper and develop the twice-exposed print, putting the intermediate print back into the water bath. Fix and wash the final print thoroughly.

USING AUTOSCREEN FILM

One graphic arts product which can offer an interesting dot screen effect for your photographs is Kodalith Autoscreen Ortho Film. We have experimented with this film and are intrigued by the results.

Kodalith Autoscreen Ortho Film is exposed and processed under red safelight conditions, with lith developer and normal stop and fixing baths. Its major difference from lith film is that it has a "built in" screen pattern, which causes small halftone dots to show in the images produced with it. In the graphic arts, the film is exposed from continuous-tone films or continuous-tone prints. During the exposure, the continuous-tone image allows varying amounts of light to pass through (or be reflected from) the areas of differing density, thus producing differences in the sizes of the dots. Then, during development with lith developer, these dots develop into their various sizes depending upon the amount of light absorbed from the initial continuous-tone subject. Thus, the original continuous-tone photograph has been broken into many black dots of different sizes. Differences in density of the continuous-tone image are now portrayed by the changes in the sizes of the dots, which visually appear to be areas of different

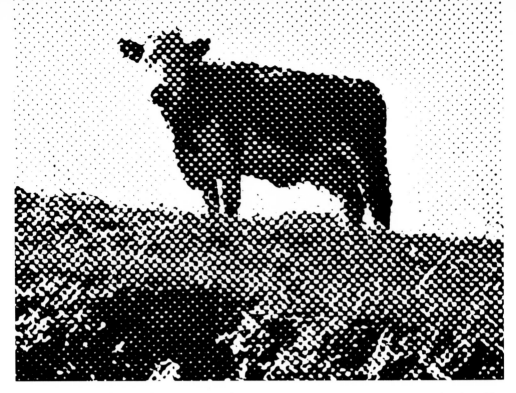

Enlargement of Autoscreen conversion from a continuous-tone negative contact printed on film. Because the original image was continuous tone, dot sizes vary in the conversion, producing an interesting effect.

tone, but actually are black dots of varying sizes.

The use of Autoscreen film for our experiments is somewhat different than its use in the graphic arts. We have found that very striking images may be produced when small, original continuous-tone negatives are contact printed directly on Autoscreen film, using a procedure similar to the "proof-sheet" technique discussed in Chapter III. Because the size of the original image is small, the dot pattern produced is enlarged when the images themselves are enlarged. The following procedure is used:

1. Prepare the lith developer, short stop and fixing baths.

2. Set up the enlarger for contact printing.

3. Working under red safelights, take a sheet of Kodalith Autoscreen Ortho Film from the box and position it emulsion side up on the contacting board. Directly over it position your continuous-tone negatives (35mm or other size), with the emulsion facing down and touching the emulsion of the Autoscreen film. Use a clean glass to provide good contact of the films.

4. Expose the continuous-tone images to the Autoscreen film for the desired time. An example of exposure might be $f/16$ for 20 seconds with a 150mm lens. Keep in mind that the density of the continuous-tone images and the exposure time used will determine the dot structure on the Autoscreen film.

5. After exposure is completed, place the exposed film in the lith developer and begin development with agitation.

6. After 30 to 45 seconds, the film image should begin to appear. Normal development time is approximately 2½ minutes at 68°F. As the dot structure is very small (especially if a 35mm negative was used) a magnifying glass may be helpful for viewing the image.

7. After development is completed, stop, fix and wash the screened high-contrast film positive. No reduction or intensification is necessary.

8. Print the resulting film positive in the normal manner to make a negative screened print of the image. If a final positive is desired, contact print the screened positive on a sheet of lith film using conventional contact printing procedures. Use the screened film negative to produce screened positive prints.

It is possible to use Autoscreen film with images which have already been converted to high-contrast form; however, in such a case the screen pattern formed will be produced only in the clear areas of the high-contrast image with all dots being uniform in tone and size.

If you wish to produce an image with smaller dot structure, then you may prefer to enlarge the continuous-tone image on Autoscreen film, instead of contact printing which provides a larger dot structure. Thus, the overall size of the image will be larger and the dots smaller.

Screen tints are used by graphic artists to apply various patterns to art work. Such patterns will provide another way to enhance certain subjects. **SCREEN TINTS**

There are basically two types of screen tints—the "dot" type and the "special effect" or "texture" type. The use of the dot screen tint (sometimes called a "plate screen") breaks down solid black areas in a high-contrast image into a pattern of uniform dots; thus the original blacks take on a gray appearance. We do not use the dot patterns much because the Autoscreen film technique applied to high-contrast images will produce the same results. However, you may care to experiment with them.

The second general classification—"special effect" or "texture" screen tints—includes patterns such as mezzotint, line, wavy line, oval, ringlet, mesh, burlap, fibril and many different wood-grain patterns. Many of the texture screen tint patterns may be combined with some of the high-contrast techniques discussed elsewhere in this book. (A Designer's Package of two dozen 9″ × 12″ texture patterns is produced by the ByChrome Company, and there are other patterns available from other manufacturers.)

Both the dot and special effect texture screen tints are supplied on film and thus can be used in contact with film or paper, or may be positioned in the negative carrier of the enlarger and projected with the film image. The procedure is described briefly as follows:

When contact printing a high-contrast negative on Polycontrast paper, the screen tint pattern may be used on top of or between the film and paper. Thus, the light passes through only the open areas of the screen tint and the open areas of the negative, producing a screen pattern in the dark tones produced by open negative areas. Both screen tint and image will be reproduced in their same size.

Contacting screen tints to film or paper with a projected image: You may have a small high-contrast negative to be projected on high-contrast paper, and desire to use a screen tint pattern. In that case, focus the image to fill the paper sheet, and then position the screen tint over the paper and in contact with it before exposure. The print will then show the screen tint pattern in the areas where light has passed through the negative, producing results similar to the first procedure utilizing direct contacting of the image. The difference is that the image will be enlarged, but the screen pattern will not.

Projecting screen tints with a contacted image: This procedure provides for the enlargement of the screen tint pattern, while the full-sized image is contacted on the paper or film. Begin by placing the selected screen tint pattern into the negative carrier of the enlarger making certain that it will cover the full film or paper area when projected on the contact board. Under safelight conditions, place a piece of paper or film on the board and cover it with the image to be exposed. Expose for the required time, thus printing the screen tint pattern through the image film sheet to the unexposed film or paper below. This procedure will enlarge the screen tint pattern but not the image.

Projecting screen tints with a projected image: This technique requires the sandwiching of the image and the screen tint in the negative carrier. Begin by placing the film negative or positive into the negative carrier, then position a section of screen tint either above or below it. Now project the entire image to film or paper on the contacting board at the desired enlargement size. In this case the screen pattern will be enlarged along with the image. Enlargement of a texture pattern makes it more interesting with some subjects, but you will have to judge such effects for yourself.

When employing texture screens you must be very careful to consider the image and not be over-influenced by the pattern. Use of texture screen patterns is very often exciting, but it may cause confusion when combined with more complex photographic techniques such as posterization, bas-relief imagery and other techniques. Generally it is wise to limit the number of texture patterns to no more than one or two designs which will harmonize with the subjects.

It is possible to make your own texture screen patterns on lith film. To do so, place a particular textured object such as cheese-cloth, a sponge, textured plastics, wire mesh and so on, in contact

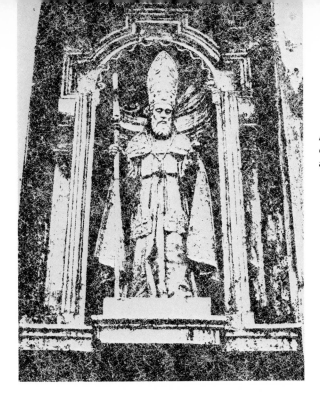

A texture screen pattern was used to enhance this high-contrast picture of a church statue.

with the film emulsion and make a suitable exposure to the lith film. The film should then be developed in lith developer, thus producing a film negative of the patterned effect. Reduction may also be needed with certain patterns so that they are more transparent and easier to use.



**MANUAL
ADDITION
OF COLOR
TO PRINTS**



These supplementary procedures provide the opportunity to produce color photographic effects without using color films or papers. There are a number of techniques available for adding color to high-contrast prints, and some of the results are difficult to achieve with conventional color procedures. Some of these techniques may not be considered "standard procedure" for photographic prints.

Both water colors and food coloring provide a great variety of different colors depending upon their mixture and application to the photographic print. With both types, a paint brush may be used to apply the color in the designated areas. Also used, with good results, is a sponge procedure where the color solution is wiped across the areas of the print to be colored. This sponge wiping action will generally produce streaks which may be desirable with some subjects. We have found that a good photographic sponge, cut into cubes approximately 2 inches square, is an ideal applicator. You might also try cotton pads and cotton swabs for color application.

With food colors, you can prepare a tray of the desired color and soak the print in it. This, of course, colors the entire print surface unless certain areas have been masked out with Miskit or a similar liquid masking material (see Masking Systems). We have found that food colors have no detrimental effect on the print. It is important that the dyed prints be allowed to dry fully before they

are touched. To avoid a mottled effect in the colored surface, do not use a conventional print dryer if the food coloring technique is used.

One other method of mechanical color addition involves the coloring of areas of the print with magic markers or other pens. Sometimes, the ink of certain marking pens, when used on photographic prints, will "bead up" because the pigment is repelled by the gelatin. Some experimentation with different pens is recommended.

Of course, photo-oil colors may also be applied to the dry photographic print using the normal procedure recommended by the manufacturer. Photo-oils have traditionally been used for portrait work in color, and may be purchased in photographic supply stores. There is no reason why they cannot be used in a less traditional manner.

USING PHOTOGRAPHIC TONERS

There are quite a large number of different types of photographic toners available from your photographic dealer. Basically toners change the black photographic image to some other color. Kodak offers quite a large variety of toners—brown, blue, sepia, gold, selenium and Poly-Toner—each with different properties and different applications. As the variety is quite large, it is not practical to discuss the individual working properties of each, but rather to suggest that you follow the instructions included in the packages of the types you decide to try.

As a general rule, toners are not intended for the toning of high-contrast prints—they are more suited for toning continuous-tone images, which have a variation of density and thus may show the effects of such toning in much more subtle ways. For example, Kodak Sepia Toner is recommended for use with Polycontrast printing papers, and according to the package instructions, approximately 1 minute is necessary in the bleaching bath prior to toning the paper. We have found that this bleaching action often takes 15 to 20 times longer than indicated with our high-contrast prints on Polycontrast paper because of the density of the printed image. Despite this very long bleaching time, we have been pleased with the effect of Kodak Sepia Toner. With selected images, the sepia toner produces a deep brown color instead of the usual black.

USING PRE-COLORED PAPERS

One very simple and effective procedure to create a black image on a colored background is to purchase photographic papers coated on a pre-colored base. Such papers are normally sold in most photographic stores in conventional sizes, and generally come in red, blue, gold, green and other colors. They usually have a contrast value in the normal range (No. 2), which makes them appropriate for continuous-tone printing as well as for high-

contrast images. (One type of colored paper, called Pastel Paper, is made by the Luminos Company.)

These papers are generally exposed and processed using exactly the same procedures as most photographic black-and-white printing papers. We have used them to provide color backgrounds for high-contrast images, working with normal exposures, high-contrast film negatives and using Dektol developer diluted with an equal amount of water. Probably the major advantage of these papers is that there is no change in darkroom procedures from the normal method of printing with Polycontrast papers. Also, these papers provide very consistent results with little change in color from wet to dry form.

Color-Key materials (Minnesota Mining and Manufacturing Company) are employed in the graphic arts industry for color-proofing procedures. Color-Key material is a pigmented photo-sensitive emulsion coated on a thin polyester support. It may be purchased in either negative-acting or positive-acting types; negative-acting material makes a positive from a negative, whereas a positive-acting color-key produces a positive from a positive. Color-Key is available in various sizes and colors, with either opaque or transparent pigment. The Rainbow Pack contains 25 sheets of different colors and is available from most graphic arts suppliers. We generally use the negative-acting, transparent Color-Key, along with the one-step negative-acting Color-Key developer. **USING COLOR-KEY MATERIALS**

Color-Key is ideal for use with high-contrast lith film images to be printed in color. It works very well when several variations of one image are used to make positives in a number of different colors. These prints are then superimposed and mounted on a piece of white mat board. Many color variations are possible here, especially when transparent Color-Key material is used and parts of the assembled images overlap, producing combination colors.

The light-sensitive coating on the Color-Key sheet must be exposed with ultraviolet light, such as a sun lamp, direct sunlight or carbon arc light. The usual incandescent darkroom enlarger is not powerful enough. For exposure, we generally set up our contacting board on a table, and position a sun lamp about 18″ above it. Basically the exposure and processing sequence for printing a high-contrast negative to negative-acting, transparent Color-Key is as follows:

1. Check that the contact board and the sun lamp are properly set up. One of your chrome reflector units may be employed to hold the sun lamp bulb.

2. Working in subdued room lighting, take a sheet of Color-Key material from the package (enough light should be available to make the proper color selection) and determine the emulsion side of the Color-Key, by scratching it or looking for the dull side.

Position the emulsion *down* on the contact board and place the high-contrast negative on top of it so that all type matter and words read correctly.

3. Use the test strip procedure to determine the desired exposure time. If the film image is 8″ x 10″, a trial exposure time with the sun lamp might be five minutes. The larger the image is, the farther the light source must be from the materials to produce even illumination and the longer the exposure. Of course, if the negative is smaller than 8″ × 10″, the lamp may be moved closer to the Color-Key material, decreasing the exposure time.

4. After the proper exposure has been given to the Color-Key sheet, remove it from the contact board and position it emulsion side up on a flat surface.

5. Pour a small amount of negative-acting developer in the center of the exposed material (no image will be visible yet) and wipe it over the entire film surface quickly with a cotton pad. Allow it to soak into the coating for about 15 seconds.

6. With light pressure, rub the parts of the coating that become loose, away from the Color-Key support with the cotton pad. Use more developer if necessary to help remove the unhardened pigment. (If certain areas which should be removed continue to remain, perhaps your exposure was too long; if the entire sheet of color emulsion is removed, chances are that the exposure time was too short. The emulsion of the Color-Key material should be down toward the contacting board surface during exposure.)

7. After complete development and visual inspection, place the imaged Color-Key material into a water bath for a short washing, then carefully squeegee dry or blot dry with paper towels to prevent water marks.

8. Align the processed Color-Key sheets to create a combination of images. These can be mounted together on white mat board with tape when the final image placement has been achieved.

It is also possible to expose Color-Key using direct sunlight. If done with high-contrast lith film images between 9:00 A.M. and 3:00 P.M., a good starting point for exposure is 30 seconds. A similar exposure procedure is described for sunlight exposure of photo-silk-screen films in the following chapter.

Silk-Screen and Multiple Images VII

Stenciling, the forerunner of silk screening, has been a common graphic process for centuries. In stenciling, images are produced by forcing ink through the open, cut-out areas of a design or mask. The use of screen mesh as a support for the stencil is a development which has occured within the last one hundred years and has provided for far more versatility in the kinds of stencils which can be produced. It is only recently that artists and graphic designers have used the silk-screen process to a great degree for the printing of both reproductions and original art. The use of the silk screening to produce original art has been named *serigraphy,* and the prints are called *serigraphs.* When the silk-screen process is used to create a copy of a work previously produced in another medium, the product is called a *silk-screen reproduction.*

We have found the silk-screen process to be an excellent method of reproducing almost any photographic image, including the posterization. This technique opens up a wide range of additional creative possibilities that were previously unavailable in the photographic processes we have been discussing, especially the application of color to images and the production of large-size images.

Since this technique is unfamiliar to most photographers, we will begin with a list of basic supplies required and then explain screen preparation, before discussing the various non-photographic and photographic silk-screen stenciling techniques that are currently in use.

BASIC SUPPLIES FOR SILK-SCREEN PRINTING

Basically the silk-screen process utilizes a sturdy wooden frame with a screen mesh stretched across it. A stencil image is then prepared, either manually or photographically and adhered to the screen mesh surface, providing a mask through which ink will selectively pass. Ink is then placed on the surface of the screen mesh and a rubber squeegee is used to carry the ink across the mesh. Thus, ink is pushed through the open mesh areas to a sheet of paper over which the screen is placed.

For the silk-screen process the following supplies will be needed:

silk-screen printing unit consisting of:
 wooden frame
 baseboard
 hinges (pin or clamp type)
 silk to cover the frame (12XX)
 squeegee (proper size to fit the frame)
gummed paper tape (two inches wide)
masking tape (one inch wide)
shellac or varnish
lacquer thinner
silk-screen inks (oil-base)
paint thinner
transparent base extender
water-soluble blockout
newspaper
assorted art papers for printing
miscellaneous supplies such as paper towels, rags, tongue depressors, paint brushes, scissors, rulers, pencils and empty containers for storage of mixed inks

SUPPLIES NECESSARY FOR SPECIFIC STENCILING TECHNIQUES

For specific silk-screen techniques the following supplies will be needed:

Paper stencil:	unprinted newsprint or vellum paper
	sharp pointed knife or razor blade
Tusche-glue stencil:	grease crayon, grease pencil or liquid tusche
	rabbit-skin glue, water-soluble block-out or rubber cement
Lacquer film stencil:	lacquer film masking material
	good quality lacquer thinner (or adhering fluid)
	sharp pointed knife, razor blade or loop knife
Aquafilm stencil:	Aquafilm masking material
	sharp knife, razor blade or loop knife
Photo-film stencil:	photo-silk-screen film (Ulano Poly Blue or Prep film)
	silk-screen film developer
	sun lamp for exposure of the film
	enzyme film remover

SCREEN FRAME PREPARATION

Silk-screen frames, usually constructed out of clear pine with mitered, lapped or interlocking corners, may be made at home or purchased precut in practically any size. In larger cities a commercial silk-screen supplier will make a frame, or frames, to

specific sizes for you. In practically every city a local art dealer or hobby shop will have silk-screen frames in precut sizes in stock, with the final assembly of the frame left to you. It is also possible for you to make your own wooden screen frames by purchasing 2″ × 2″ clear pine and mitering or lapping the corners. Whatever procedure you utilize to obtain a screen frame, the final product should be a frame that is strong, will not bend or warp with the many solvents and mesh stretching, and will last for years. After the frame is purchased and assembled, it may be varnished to protect the wood.

At this point the screen mesh can be stretched across the frame. You will find that 12XX or 14XX silk mesh will be most suitable for the types of work you will want to do. Other fabric meshes and stainless steel mesh are also available, but lack some of the desirable characteristics of the silk fabric. If you purchase a ready-made screen from a commercial silk-screen supplier, the frame may come with the mesh already stretched across it; 12XX is considered the normal mesh in most cases. However, if you make your own frame, or buy the frame pieces precut but not assembled, you will have to stretch the silk across the frame yourself. In any case, you will need to know how to change the screen mesh as it becomes worn. It is a good idea to keep spare mesh available for replacement should your screen mesh inadvertently become snagged, torn or develop a hole.

There are a number of ways the mesh may be attached to the frame. One method is to lay the screen mesh across the back of the frame, and pulling from opposite sides, carefully fasten the mesh to the wooden frame with tacks or a staple gun. Another technique, which is popular with many commercial houses, is to have the frame built with a routed groove around the bottom of all four sides. Into this groove a ¼″ plastic (or cloth) cord is pushed, or force-fit, pulling the mesh taut from all sides as the cord slides down into the groove. The advantage of the stapling method is that frame construction is much simpler because no routing is required; the advantage of the routed groove is that quick mesh changes are possible.

After the mesh has been stretched across the frame so that it is taut, taping with a paper base tape along all edges where the frame meets the silk is necessary. To do this, you will need four pieces of tape corresponding to the inside dimensions of the frame. Each piece will be folded in half lengthwise so that half of the tape will be adhered to the inside of the wooden frame, and the other half to the mesh. It is best to begin on one side of the screen and then turn it a quarter-turn to tape the next side, keeping the tape wrinkle-free and making certain that the corners overlap. After the inside edges are well-taped, the frame should be turned over and four more pieces of the moistened paper tape applied to the back of the

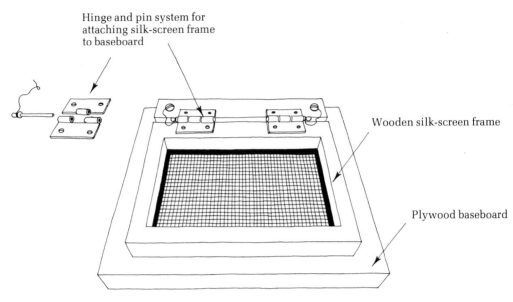

Hinge and pin system for attaching silk-screen frame to baseboard

Wooden silk-screen frame

Plywood baseboard

Top view of a silk-screen printing unit.

screen frame mesh. These tape strips should "back up" the tape on the mesh of the front side of the frame closely. Second and third layers of paper tape may be applied to both sides of the frame, over the first tape, for a more long lasting screen.

After the tape has been allowed to dry thoroughly, several coats of varnish should then be applied to fasten it firmly to the wooden frame and screen mesh, creating a very strong seal. Be careful when applying the varnish so it does not spatter onto the screen mesh, as it will clog the mesh if allowed to dry. The purpose of varnishing is to preserve the screen and to completely seal off the edges and corners. This provides for easier and more thorough cleaning, with less chance of accumulated ink and solvent build-up in these areas. Residual ink and solvents may rot the mesh if in contact with it over a period of time. If varnishing is not done, the tape is generally removed from the screen after each use, applying new tape before next using the screen.

The completed screen frame must now be hinged to some type of baseboard so that the frame can be raised and lowered in register. Probably the most versatile method of hinging the screen to the baseboard is with a pair of specially designed screen frame clamps. Your silk-screen supplier has these available in different varieties and under different names, but they are generally known as "hinged screen frame clamps." One pair of these hinged clamps, mounted on a smooth, flat plywood baseboard ($1/2''$ thick or more) will allow the use of any number of screens, one at a

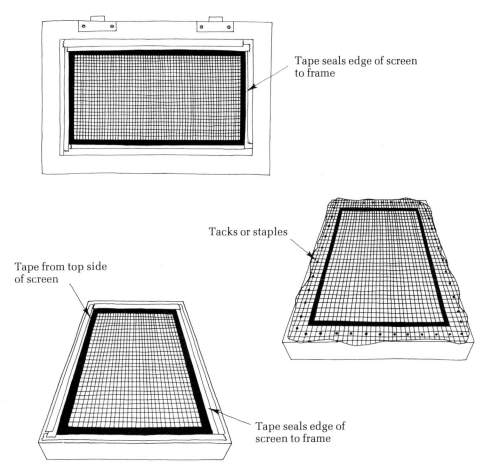

Tape seals edge of screen to frame

Tacks or staples

Tape from top side of screen

Tape seals edge of screen to frame

Taping of screen mesh to wooden frame (top). Bottom view of the screen frame with screen mesh stretched (center). Bottom view of the stretched screen indicating taping (bottom).

time. The screen frame is secured in the clamps which are hinged to the baseboard and held firmly during the press run. When a screen change is needed, the clamps are loosened, the used screen is removed, and a new screen inserted and clamped tightly. The plywood baseboard must provide a smooth flat surface and a good base for the clamps. It should be slightly larger than any of the screen frames to be clamped to it.

A second method of hinging the screen to the baseboard (many artists and screen-printing operations use this method) is to purchase a pair of ordinary loose-pin hinges and a wooden bar the same dimensions in height, width and length as one side of the screen frame. A sheet of smooth plywood, at least $1/2$-inch thick and slightly larger than the screen frame, will also be needed. The wood strip must be well secured along one edge of the plywood

baseboard. The pair of hinges should then be attached to the top of the wood strip, near the ends of the strip, and to the wooden screen frame using wood screws. Be certain that the mesh of the screen is close to the baseboard surface. Note that if you intended to use more than one screen with the loose-pin method, you will need hinges of exactly the same size, in exactly the same positions with each screen frame, so that all will be able to interchange on the single baseboard.

Removal of screen frames from the baseboard support, with either the hinge or clamp method, is necessary when removing and adhering the image to the screen mesh, and for cleaning and changing of the mesh. This screen-frame interchanging will be done throughout the various stenciling processes.

After a screen has been used to print a number of images, a "ghost" image or stain will appear on the mesh. This "ghost" image comes from inadequate removal of the stencils and inks used on the screen. To remove this residue, we recommend enzyme cleaners which are available from your silk-screen supplier. It may be impossible to remove the "ghost" image entirely, but always be certain that the screen mesh is not clogged with the "ghost" effect.

Another problem, inherent with silk-screen printing, is drying of ink on the screen causing clogged areas. For the removal of dried inks, first attempt normal washing with the usual solvent used for cleanup, such as paint thinner for oil-base inks. If this is not successful, use a small amount of lacquer thinner, working both sides of the screen at one time (holding it vertically) with the solvent on two rags or paper towels. Oil-base inks which have dried on the screen can usually be removed in this manner.

For further information related to solvents and inks used, consult the chart provided on pages 136 and 137. Remember that you will minimize your printing problems if you keep the screen clean, and replace any mesh which becomes worn or frayed.

NON-PHOTOGRAPHIC SCREEN STENCILING TECHNIQUES

After the screen has been properly prepared, a stencil must be produced and adhered to the screen mesh. There are a number of different types of stencils, each employing a different stenciling procedure; all produce a "mask" that prevents ink from passing through the screen mesh. The types of stencils described below are all non-photographic in nature, and may often be used in place of the photographic stencil (to be discussed separately) in the production of extremely large, undetailed image areas or for images where the production of a high-contrast film positive would be difficult or unnecessarily costly. For a quick comparison of the different types of stencils, consult the chart on pages 136 and 137. Each type is also described briefly as follows:

Paper stencil: The paper stencil is the least expensive and

easiest stencil to prepare. It is normally cut with a sharp knife or razor blade from vellum or unprinted newsprint. It is best used for blocks of color and designs that have little detail. After the stencil image is cut in the desired design, cutting away those areas to be printed so that ink will pass through them, it is adhered to the screen by ink forced through the mesh. The ink acts as a glue to hold the stencil in place during the press run. Small bits of masking tape may also be used to secure the paper mask in some cases. Although the life of the paper stencil is limited, it is popular because of its simplicity and low cost.

Tusche-and-glue stencil: The tusche-and-glue stencil is not generally considered a production type of stenciling process; it is more a fine art technique. This method of silk screening is time-consuming, but it will often produce beautiful images. It is difficult to produce intricate detail with the tusche-glue procedure, although it is possible to achieve more spontaneous painterly effects than with the other stenciling techniques.

Briefly, the tusche-and-glue stencil is made using liquid tusche, or a grease pencil or crayon, to draw the desired image on the screen mesh. After the tusche has been applied to all image areas, a glue mixture, or water-soluble blockout, is spread over the screen surface and allowed to dry completely. After the glue is dry, the screen mesh is flooded with lacquer thinner and scrubbed carefully to remove the tusche, allowing the dried glue to remain. The glue which is retained on the screen provides the stencil image, that blocks ink when printing.

Lacquer film knife-cut stencil: This type of stencil is probably the most popular non-photographic stencil in use today. It is extremely tough, with long-run capability, yet it retains fine detail over the entire stencil life. You can purchase the lacquer film material from your silk-screen supplier. It is not particularly expensive, and it is very easy to cut and adhere to the screen mesh.

The stencil consists of a thin layer of lacquer supported on a paper backing sheet. For use, the areas to be printed are carefully cut in outline form with a sharp knife or razor blade (or a loop knife if a line image is desired). Care must be taken not to cut through the paper backing sheet or any copy placed underneath the stencil to serve as a guide for cutting. After cutting is completed, the portions to be printed are carefully peeled away from the paper support, leaving the lacquer film attached to the support in the non-image areas.

After cutting and peeling, the lacquer sheet should be placed on a small stack of newspaper, coated side up, and the dry screen mesh placed in direct contact with it. If any type matter is evident in the image, it should read correctly. At this point a cotton pad should be soaked with a good quality lacquer thinner or a special

lacquer-film adhering fluid purchased from your silk-screen supplier. Starting at the top left corner of the film, apply the thinner across the screen mesh. It is best when carrying out this adhering process to work in only one area at a time, saturating that area with lacquer thinner then using a dry cotton towel (or paper towel) to quickly blot up all excess liquid. Work quickly when doing this; an excess of thinner will cause the film to "burn" or dissolve, ruining your image. A light pressing action when blotting with the dry towel will help the softened film to adhere to the mesh of the screen. With most types of lacquer film the adhering process will turn the film a darker color—it is usually a green or brown in color. Poor adhesion will be immediately noticable because the film will not darken.

After the adhering process is completed, the screen with the attached lacquer film image, including backing sheet, should be allowed to dry thoroughly in a well-ventilated area. This will generally take from five to thirty minutes. Once dry, the backing sheet may be carefully pulled away from the screen mesh, leaving the lacquer film image on the screen. If, when peeling, any film should remain attached to the paper backing sheet, stop peeling and allow it to dry fully. Use more lacquer thinner to re-adhere that area of lacquer film to the screen mesh. After successful removal of the paper backing sheet, water-soluble blockout may be used to cover the edges of the screen which the lacquer film does not cover. Once this blockout is dry, printing may begin.

Remember that when using the lacquer-film stencil, lacquer-base inks may not be used for printing, as they will dissolve the stencil during the press run. Also, do not use lacquer thinner or products containing similar lacquer solvents during cleaning, as they too will dissolve the stencil. Cleaning with turpentine or paint thinner will be acceptable when printing with oil-base inks.

To remove the stencil from the screen mesh, simply soak it in lacquer thinner. This may be easily accomplished by placing the screen mesh in contact with newspaper and then flooding the screen mesh with the lacquer thinner. After a minute or two, the stencil will dissolve (rubbing it will help), and final cleanup may begin. Be certain to wash the screen thoroughly in water to remove the water-soluble blockout used around the perimeter of the lacquer-film image, and check that the screen mesh is completely clean before the next image is attached.

Aquafilm knife-cut stencil: The (Ulano) Aquafilm stencil bridges the gap between the knife-cut lacquer-film stencil and the photographic silk-screen stencil. The Aquafilm stencil works much like the lacquer-film stencil, except that the adhering solution is water (or isopropyl alcohol and vinegar). The inks used may be oil- or lacquer-base; water-base inks will dissolve the Aquafilm image. The cutting of the stencil with a knife, razor

Information about the
images in this color
section is on the page
following color plate 14.

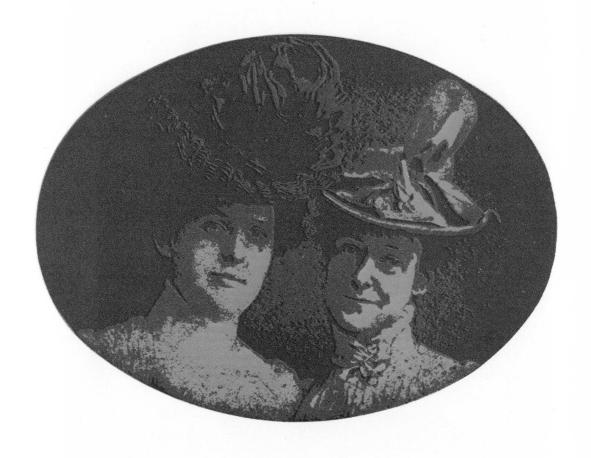

COLOR PLATE 1

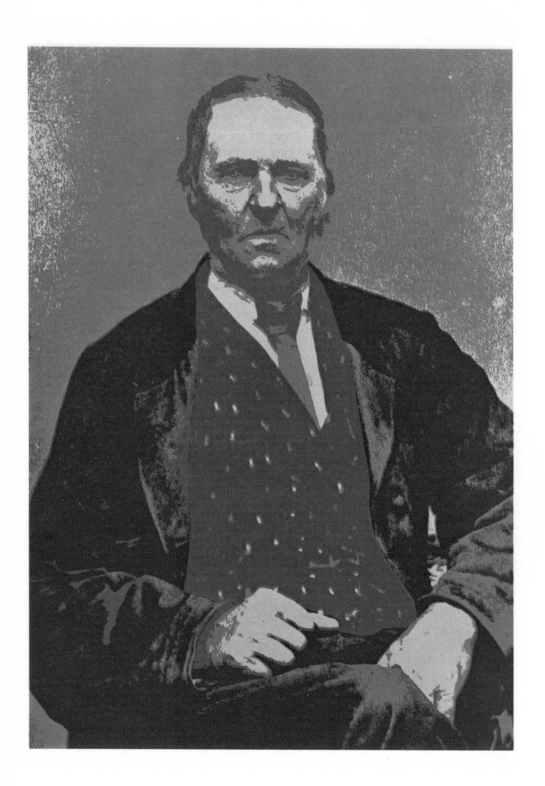

COLOR PLATE 2

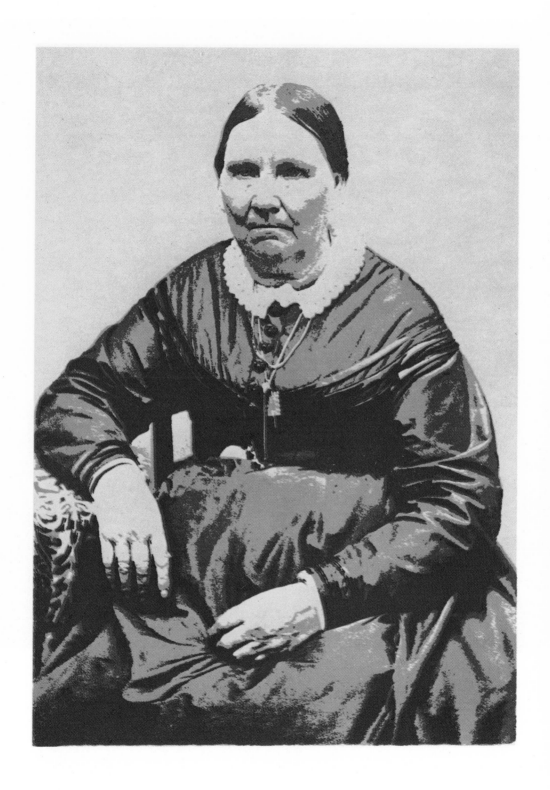

COLOR PLATE 3

COLOR PLATE 4

COLOR PLATE 5

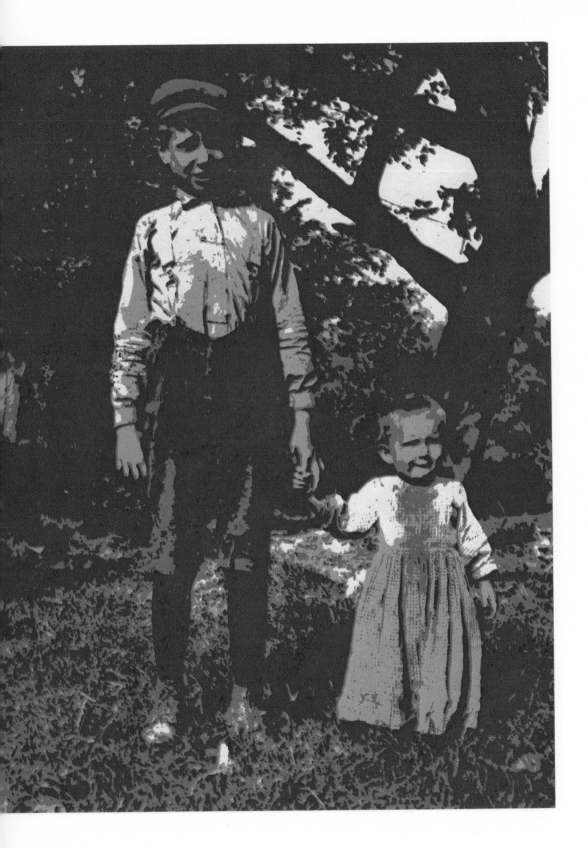

COLOR PLATE 6

COLOR PLATE 7

COLOR PLATE 8

COLOR PLATE 9

COLOR PLATE 10

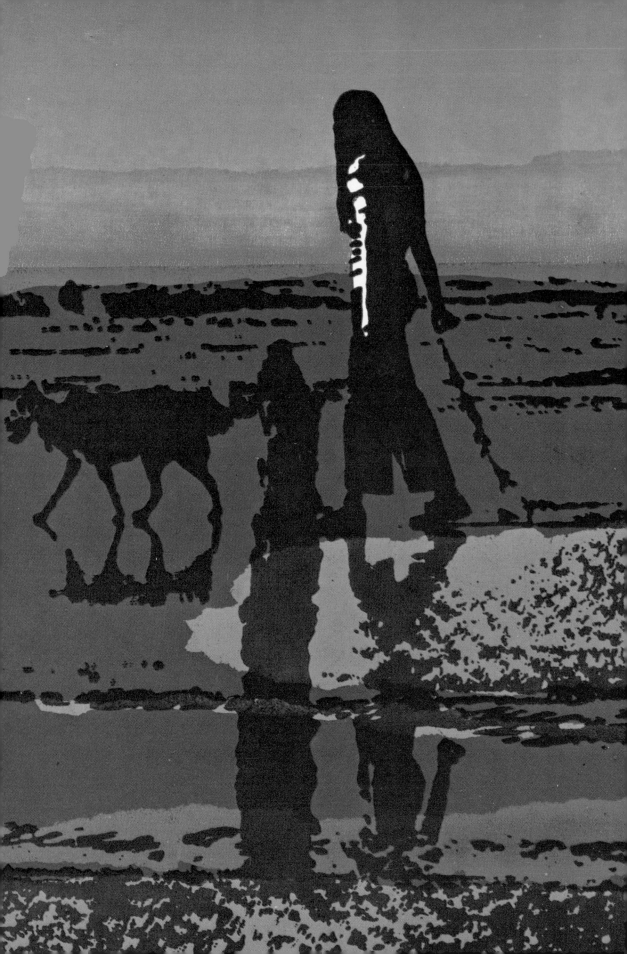

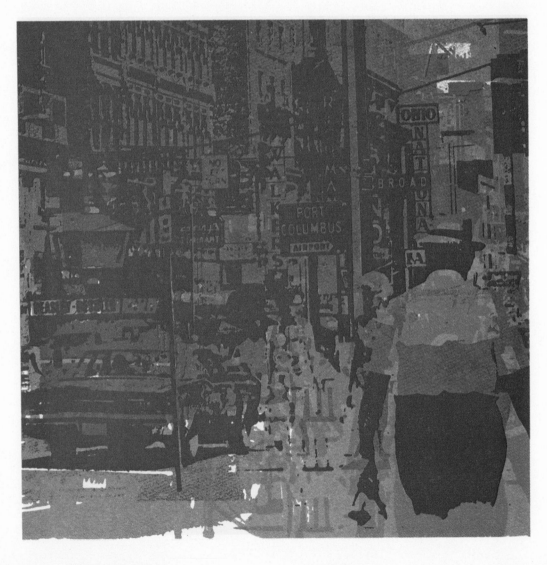

COLOR PLATE 12

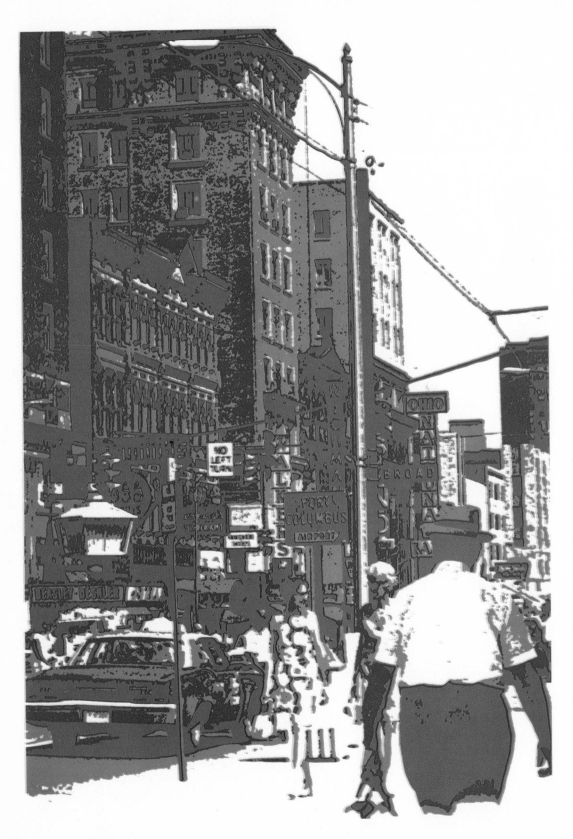

COLOR PLATE 14

Faith and Hope, Two Spinster Aunts. This three-color posterization was created with one positive and two negative printers, as well as various filter exposures. **Color Plate 1**

Hiram Haskell. Serigraph employing four-tone posterization and photo-silk-screen techniques. An extra mask was used to print the fifth color in the vest. **Color Plate 2**

Hazel Haskell. Serigraph employing four-tone posterization and photo-silk-screen techniques. **Color Plate 3**

This color print of a building in Florence was created with high-contrast images of the building and the moon, as well as an initial exposure to provide background color. **Color Plate 4**

The stained glass window image was greatly enhanced by the application of color with felt-tip pens. **Color Plate 5**

Two Friends. Serigraph employing four-tone posterization and photo-silk-screen techniques. **Color Plate 6**

Mandala (magic circle). High-contrast image silk-screened over a solid color background made with a simple paper stencil. **Color Plate 7**

Pismo Evening. Serigraph created by printing a single high-contrast image over the background consisting of a series of colors, which were applied using torn-paper techniques. **Color Plate 8**

Brunswick Pool and Billiards Bowling Alleys. Serigraph employing four-tone posterization and photo-silk-screen techniques. **Color Plate 9**

Porches. Image-reversal technique (Chapter VI) printed in various colors. **Color Plate 10**

Cat Canyon Reunion II. Serigraph employing four-tone posterization and photo-silk-screen techniques plus the manual application of additional colors. **Color Plate 11**

Columbus. Four-tone posterization employing photo-silk-screen techniques. The three screen-image separations are each printed in a different color. **Color Plate 12**

Columbus Monoprint I. Variation of the Columbus image utilizing random multiple printing of the various screen-image separations in different colors. **Color Plate 13**

Columbus Monoprint II. Another monoprint variation. **Color Plate 14**

blade or loop knife is done exactly as with the lacquer film. Be careful not to cut through the paper or plastic backing sheet. Also, remember when peeling away the areas of the mask, through which the ink will flow, that the edges formed should be sharp and clear, and that tearing of the film will lead to the loss of image crispness. Sometimes the use of loop knives with Aquafilm is difficult, because the film coating is thick and tends to tear more readily along the cut edges.

Adhering the Aquafilm to the screen mesh is done like the lacquer-film method, except that the adhering solution should be plain water, or three parts of water with one part of isopropyl alcohol, or an equal mixture of isopropyl alcohol and vinegar. A cotton pad should be saturated with the adhering solution, then beginning at one corner of the film image (which has been placed directly under the screen mesh, on newsprint) wipe the entire width of the film. Using a dry cotton rag or paper towel, remove all excess solvent by blotting. The application of light pressure during blotting will help adhere the softened Aquafilm emulsion to the screen mesh. After this wetting and blotting technique has been completed in one area, move to another section and quickly repeat the technique. Regardless of the adhering method you employ, keep in mind that too much solvent will dissolve the film image and ruin it. Work quickly when wetting the film and blotting it dry.

After the adhering process is completed, allow the film to dry completely, which should take from 20 minutes to a few hours. After it is dry, carefully peel the backing sheet from the film. If any part of the film peels away, stop and try to re-adhere that area to the screen. After the backing sheet has been removed, water-soluble blockout may be used to cover the edges of the screen not covered with Aquafilm, or to touch up non-image areas. When the water-soluble blockout is dry, printing may begin.

Removal of the Aquafilm stencil is easily done by placing the screen frame in a sink and allowing warm-to-hot water to flow over it for a short period of time. This will also remove the water-soluble blockout and help to clean the screen mesh thoroughly in preparation for the next image.

Photographic Silk-Screen Stenciling Techniques

Some of the most exciting work done by silk screen today uses the photo-silk-screen technique. This process is ideally suited for use with the high-contrast photographic images discussed in previous chapters. It provides for excellent renderings of photographic detail and is particularly suited to the printing of posterizations in color. The photo-silk-screen film emulsion is exceptionally tough in structure and yields long press runs.

To explain the process briefly, a photographic stencil is made by exposure of a transparent positive image in high contrast, such as a high-contrast lith film positive, a positive drawing in india ink on clear mylar, acetate or translucent paper, or a Rubylith high-contrast mask, to a sheet of presensitized screen process photographic film. Exposure is usually done with a high-intensity ultraviolet light source such as a sun lamp, carbon-arc light or direct sunlight; the light rays harden the film emulsion in those areas not covered by the opaque image. After exposure, development is done in a photo-silk-screen developer, and then a warm water "wash out" is used to remove the unhardened stencil portions from the film base. A cool water rinse is then used to begin the hardening of the emulsion remaining on the support base, immediately before it is adhered to the silk-screen mesh. The adhering process involves direct contact of the film to the underside of the screen mesh, using gentle blotting to remove excess water. After the film has dried completely, the film support base is peeled away from the screen mesh, allowing the hardened film emulsion to remain affixed to the mesh. Water-soluble blockout is then applied to all necessary areas, and when dry, printing of the image may be completed.

We have tried a number of different kinds of commercial silk-screen film and have had good results with Ulano Poly-Blue-2 presensitized screen process film and Ulano Prep presensitized photo-film. These photo-silk-screen films consist of a gelatin coating, sensitive to ultraviolet light, mounted on a 0.002" (2 mil) polyester support base. The film is quite easy to use, does not have to be used in a darkroom, is excellent for fine lines and detail areas, adheres well to silk-screen meshes, has a very tough emulsion which allows long press runs, and it can be easily removed from the screen mesh when the run is completed.

PHOTO-SILK-SCREEN FILMS

Photo-silk-screen films are exposed through high-contrast film positives or other positive images. If high-contrast film images are not used, designs may be drawn on acetate, mylar or even some translucent papers, preferably with india ink or other opaque pigments. Mechanical masking materials such as Rubylith will also be suitable. All images to be exposed on these photo-silk-screen films must be made in the exact size desired, since these materials can only be printed by contact. You cannot enlarge a photographic image on Poly-Blue or Prep films because the incandescent enlarger light does not produce enough ultraviolet rays to expose the film.

To prepare an image in high-contrast form on lith film, the simplest method is to expose a continuous-tone negative to a lith film sheet for the necessary time, then develop it in lith developer, thus producing a lith film positive. Reduction, intensification and

opaquing should then be used to produce a high-contrast film positive suitable for photo-silk-screen film exposure. If you begin with a film negative already in high-contrast form, it simply needs to be printed on a sheet of lith film, then developed in lith developer, to produce a high-contrast film positive. If a posterized image is desired, prepare the posterization separations correctly and then produce them in the desired size in positive form for contact printing to photo-silk-screen film. Be sure that your positive posterization separations are all exactly the same size. If they are not the same size, accurate registration of the posterized image during the printing process will be impossible. With whatever technique you use in the preparation of your positives for exposure on photo-silk-screen film, it is essential that the images are opaque, clean and crisp.

Photo-silk-screen film is normally sold in large sheets rolled and stored in a tube. One popular size is 40″ × 150″ but other sizes are available. The film should be handled under subdued lighting conditions for cutting, exposing and developing. Low-level incandescent or fluorescent lighting is best, as both sources produce little ultraviolet light. Pre-exposure of the photo-silk-screen film to even small amounts of direct sunlight or other ultraviolet sources could cause trouble.

Working under subdued lighting conditions, cut a piece of photo-silk-screen film larger on all sides than the film positive by one inch. (For example, a piece of silk-screen film for an 8″ × 10″ positive should be approximately 10″ × 12″ in size.) After cutting, return the remaining photo-silk-screen film to its container and seal it securely.

EXPOSURE OF THE FILM

For exposure of this 10″ × 12″ sheet of photo-silk-screen film, two convenient light sources are available—a sun lamp or direct sunlight. The sun-lamp method should begin with the placement of the silk-screen film, emulsion side (dull side) down, on a flat, nonreflective surface such as your darkroom contacting board. Over the silk-screen film the high-contrast film positive is now centered, making sure that any type matter or image is *wrong-reading.* Over these two films, place the piece of clean contacting glass, allowing the weight of the glass to produce good contact.

When using the sun lamp for exposure, position the lamp approximately 18″ above the glass-film sandwich, and expose for between 5 and 8 minutes. If the film is smaller than 8″ × 10″, then the light may be moved closer to the films, allowing for a shorter exposure time. If, on the other hand, the films are larger than 8″ × 10″, the sun lamp may need to be moved farther from the contacted films, increasing the exposure time. Use of a test strip for exposure determination may be necessary. Remember that the edges of the photo-silk-screen film sheet, that is, the area outside

the positive image, must be exposed sufficiently to provide an opaque border.

If you prefer to use direct sunlight for exposure, you should make all preparations in subdued lighting and then transport the exposure unit to the exposure place. This is best done by taping the photo-silk-screen film sheet, emulsion down, to the contact board, and then taping the film positive image over it securely. Be sure any type matter or words are *wrong-reading.* The taping will keep the films in register during transporting and exposure. Cover these two film sheets with the clean contacting glass, and over this, a sheet of stiff cardboard or mat board. It is best to use a board the same size as the contact board for ease in transporting.

Carefully carry the entire unit out-of-doors and place it in such a position that direct sunlight will strike the film when the cardboard is removed. When all is in readiness, slide the cardboard sheet quickly away from the glass and film, and expose the silk-screen film for approximately 60 sec. Be sure that once the sunlight exposure has begun the film sheets are not moved, otherwise the resultant imagery will be fuzzy or double-exposed. At the end of 60 sec. quickly cover the film with the cardboard and carry it into an area of subdued lighting, preferably where development may be carried out.

The direct sunlight exposure technique works best between the hours of 9:00 A.M. and 3:00 P.M., when the sun is high in the sky, and ultraviolet radiation is ample. If the day is cloudy or overcast, ultraviolet rays will still be present; however, exposure will be longer, and some experimentation may be necessary. It is also recommended that you use the test strip procedure when initially attempting this sunlight exposure technique so that you are assured good results with no waste of silk-screen film and time.

Exposure plays an important part in both the appearance of the image and the length of run of the screen. If the exposure is too long, the imagery will fill-in in the fine line and detail areas, but the length of run of the screen will be increased. If the exposure is too short, details may be sharp but the screen will not last long.

DEVELOPMENT OF THE FILM

Exposure allows ultraviolet light to pass through clear areas of the film positive and harden the photo-silk-screen emulsion. Black film areas prevent the photo-silk-screen film from receiving exposure and becoming hardened. After the image has been exposed in contact with the photo-silk-screen film for the necessary time, it must be developed. This development is easily done using the developer specifically manufactured for silk-screen films under the name Ulano Photo-Silk-Screen Developer. This developer is normally supplied in "A" and "B" powder form. The packets contain premeasured quantities of developer, and must be dissolved in 16 ounces of water at room temperature just before

use. Directions for use are printed on the outside of each packet.

The exposed film sheet should be immersed in the solution, then turned and developed emulsion side up for between 2 and 3 minutes with agitation. Subdued room lighting is used during development. Also, the development technique should be timed—almost no visible image appears on the film sheet during the process.

This development process chemically softens non-image areas of the film, that is, those areas which were black in the film positive. At the end of the 2–3 minute developing time, the film should be carefully removed from the developer and transported to a sink for wash out. This may be simplified if the film sheet is placed emulsion side up on the back of a smooth photographic tray or piece of glass. While handling, be careful that the film does not slide off the tray and that nothing touches the very soft film emulsion.

After the film is removed from the developer, the solution should be covered with the sheet of cardboard to protect it from light. The developing bath may be used for a number of photo-silk-screen films once it has been mixed. However, because it emits a strong gas, storage of the developer in any stoppered container over a period of time is not recommended. As the developer becomes worn out, or becomes spoiled, it will cause the gelatin emulsion of the silk-screen film to crinkle and float off the backing support during the wash-out procedure. If this occurs, the exposure must be remade using a new sheet of photo-silk-screen film and fresh developer.

WASHING OUT THE FILM

With development completed, the washing-out procedure follows. This begins with the adjustment of warm tap water to 92–100°F., and then the gentle spraying of the warm water over the entire emulsion surface. The running water will cause the nonhardened areas of the film to dissolve and wash away, thus producing a visible image on the film. This warm water wash-out usually takes between one and three minutes. After all loosened emulsion is washed away, and the image is clear and distinct, a 30 sec. cold water rinse should be immediately begun to set the emulsion. With completion of the cold water rinse, the still-slippery film should be held over the sink allowing all excess water to drain off its surface. The silk-screen film negative image is now ready to be adhered to the screen mesh.

ADHERING THE FILM TO THE SCREEN MESH

The wet, slightly jelled film sheet should now be positioned, emulsion side up, on a prearranged and slightly built-up area larger than the film size, but smaller than the screen mesh dimensions. A few sheets of newspaper will do for this purpose.

Over the wet film sheet, the silk-screen frame should be positioned, with the screen mesh resting on the film. The positioning of the film on the screen should be determined before contact is made. After contact of the two materials is made, the weight of the screen should be allowed to exert a slight downward force on the film surface.

Gentle blotting should now be employed to remove excess water from the silk-screen film, using unprinted newsprint, blotting paper or paper towels. Make certain that no lint or other residue is left on the screen surface. This blotting is not intended to press the screen mesh and the film gelatin together, so only light pressures are used here. If too much pressure is applied during blotting, or if too much water is allowed to remain on the screen mesh at the end of the blotting procedure, the image may spread and be spoiled. You may find that dampening the screen mesh with a small amount of water, before adhering your stencil, may make adhesion easier.

After blotting is completed, the screen with the photo-silk-screen film attached should be set aside so that it may dry thoroughly. Drying time may vary from 30 minutes to 24 hours and may be shortened by fanning or by the gentle application of warm air. Do not leave a freshly adhered film image in sunlight or in an area of abnormally high temperature as it may melt.

With the screen and film both dry to the touch, the backing support sheet for the film should be carefully peeled away from the screen and discarded. Do not attempt to remove the film support until the screen and film are entirely dry. The peeling action used should be smooth and easy, leaving the emulsion securely attached to the silk-screen mesh. If the removal of the backing is premature, parts of the image may separate from the screen mesh and remain attached to the backing sheet. Little can be done to correct such damage.

If the image appears acceptable, water-soluble blockout should be applied to all areas not to be printed, especially along the extreme edges between the image edge and the frame sides. A very simple procedure to apply blockout is to spread it over the area to be covered with a small piece of stiff cardboard or mat board, carefully smoothing it so that it will dry quickly. Also, minor image touchup may be completed by hand application of the blockout to the screen image itself, but this may become a very, laborious task. Water-soluble blockout generally dries in one hour or less if properly applied and will remain on the screen until it is washed off during the process of removing the photo-silk-screen film image. At this point the screen is ready for printing.

As you will note on the chart on page 137, there are many different types of silk-screen inks. Oil- and lacquer-base inks are **INK AND PAPER**

Type of Stencil	Approximate Length of Run	Cost	Detail Potential
Paper	Fairly short; depends upon type of paper used	Very inexpensive	Carries minimum detail
Tusche-glue	Moderate	Fairly inexpensive	Carries fair detail
Lacquer film	Fairly long	Moderately expensive	Good detail
Aquafilm	Fairly long	Moderately expensive	Good detail
Photo-silk-screen film	Very long	Fairly expensive	Excellent detail

Type of Ink/Type of Solvent	Stencil Preparation	Method of Adhering	Stencil Removal
Oil base/paint thinner Enamel/kerosene Fluorescent/ turps, naphtha Lacquer base/ lacquer thinner Tempera/water	Paper may be cut with knife or razor blade; also may be torn for interesting effect	Ink adheres paper stencil to screen mesh; masking tape may also be used	Peel paper off screen
Oil base/paint thinner Enamel/kerosene Fluorescent/ turps, naphtha Lacquer base/ lacquer thinner	Image is drawn or painted on screen mesh with tusche or grease crayon; glue is used to fill in negative areas	Natural adhering of glue to screen mesh; removal of tusche with lacquer thinner required	Remove glue with warm water bath
Oil base/paint thinner Enamel/kerosene Fluorescent/ turps, naphtha Tempera/water	Emulsion is cut or scribed, then image areas are peeled off support	Lacquer adhering solution is rubbed over screen and film with blotting action to help adhere film to screen mesh	Remove by saturation with lacquer thinner
Oil base/paint thinner Enamel/kerosene Fluorescent/ turps, naphtha Lacquer base/ lacquer thinner	Emulsion is cut or scribed, then image areas are peeled off support	Water, isopropyl alcohol or vinegar in same manner as with lacquer film procedure	Remove with warm water bath
Oil base/paint thinner Enamel/kerosene Fluorescent/ turps, naphtha Lacquer base/ lacquer thinner	Image drawn in positive form on acetate, paper, or Mylar; high-contrast lith film positive	Film exposed then developed; washed out with hot water bath; jelled with cold water bath; blotted when wet to adhere to screen mesh	Remove with hot water and enzyme cleaner

very popular and are probably used for the majority of imagery produced with the silk-screen technique. Also used, but less often, are the water-, fluorescent- and enamel-base types. The type of ink you select will depend on the type of stencil used for the screen image, the substrate to be printed upon, the type of blockout used and the solvents to be used for cleanup. Such decisions should be made before the image is placed on the screen and should be discussed with your silk-screen supplier before the purchase of supplies.

Oil-base inks, which we usually use, are thinned with paint thinner and extended to provide greater covering power with transparent or opaque extenders which do not affect color. For use on the screen, most inks are diluted so that their consistency is about that of honey. To prepare a color for printing, it should first be mixed, beginning with the lighter color and adding the darker ink to it. When the desired color is achieved, it should be thinned and extended until a suitable consistency has been obtained. Oil-base inks are usually very strong in pigment, generally quite opaque, and as a rule, dry in 30 minutes or less. Final drying time depends upon the type of pigment, the amount of thinner and extender used, the porosity of the paper, the size of the image and other variables.

The amount of ink to be mixed depends upon the size of the image to be printed, the number of copies desired, the consistency of the ink and the porosity of the paper being used. We have found that experience is the best judge here and that no hard and fast rules apply. After an image has been run, any excess ink can be saved in a well-sealed container for use at a later date (empty coffee cans or margarine tins can be used). Sometimes a small amount of paint thinner can be poured on the surface of oil-base inks to keep them from forming a crust.

When mixing inks for a special color, mix enough ink for the entire press run, to ensure consistent color rendition. It is far better to mix more ink of a particular color and have some remaining (which may be used with other ink for mixing of the next color), than to run out of the special ink color and attempt to match it in the middle of the run.

The type of paper to be printed upon will have a bearing on the type of ink you select to use. With most paper substrates we recommend oil-base inks, though others may also be suitable. We find that oil-base inks work well with photographic stencils, water-soluble blockout and most of the papers we use. Oil-base inks are also easily obtained and they are less expensive than some other types.

Cleanup of oil-base inks is usually done with turpentine or paint thinner. If you intend to print on unusual materials, such as plastics, mylar, glass, cloth and so on, it would be best for you to

find out the types of inks recommended for those materials. You might find yourself limited to one or two types of stencils, depending upon the ink base and the cleanup solvents required for printing on those materials. (See chart on pages 136 and 137.)

With screen preparation completed and inks mixed, the matter of registering the image so that it will print in the same position on succeeding sheets of paper must be considered. Such registration procedures correspond to the pre-exposure punching and tab-pin register systems which have been discussed for darkroom work, although the use of pins is not practical in this case.

REGISTRATION OF THE IMAGE

Registration is begun by attaching the screen frame to the hinges or clamps. The plywood baseboard, onto which the hinges or clamps are attached, should be covered with one or two thicknesses of kraft paper or newsprint to provide a clean, smooth working surface.

Registration tabs must now be made and are best cut from paper as heavy as matchbook cover paper. The shape of these tabs when folded resemble the letter w, and each press run will require three

Placement of the w tabs on the baseboard.

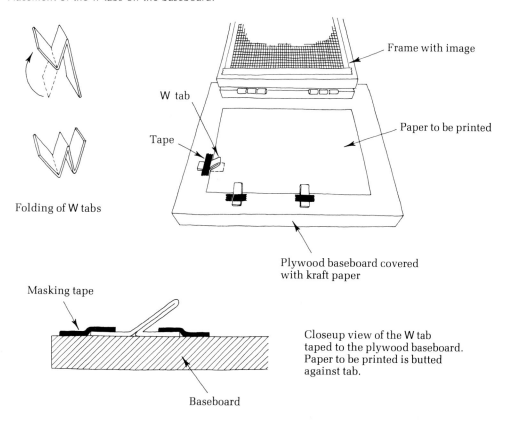

Frame with image

W tab

Tape

Paper to be printed

Folding of W tabs

Plywood baseboard covered with kraft paper

Masking tape

Baseboard

Closeup view of the W tab taped to the plywood baseboard. Paper to be printed is butted against tab.

such tabs for accurate registration. After the three tabs have been folded, they are taped to the baseboard—two tabs on a long side and one on a short side (see illustration on page 139). In printing, the paper is slipped onto the baseboard and butted up against the tabs. This procedure is followed for each sheet to be printed, thus assuring exact image register from one printed sheet to the next. You will probably find that each new screen image will require repositioning of the tabs on the baseboard, unless film placement during the adhering process was controlled exactly. If masking tape is used to fasten the tabs to the baseboard, there will be little problem in reusing them.

Tab placement may be done in a number of ways. One technique is to determine by measurement the approximate image and sheet positions, tape down temporary tabs, then move the tabs to the final position after one or two impressions at the beginning of the press run. A second technique involves the printing of the image directly on the baseboard (which has been covered with kraft paper), then using a pencil and straight edge to determine sheet edge placement. The tabs are then taped at the marks. A third technique (helpful when registering a sheet that has already been printed with one color) is to print a test image on a sheet of clear acetate or transparent paper that is larger than the paper size being used, and that has been taped securely to one side of the baseboard with masking tape. A sheet of paper containing the preprinted image is then slipped under the acetate and aligned as desired. Now holding the paper so that it does not move, the acetate sheet should be flipped out of the way and a pencil used to mark accurately the two sides of the sheet where the register tabs will be placed. After the tabs have been properly positioned, the acetate sheet may be removed and cleaned with solvent for reuse.

You will find, when doing multicolor silk-screen printing, such as with posterizations, maintenance of registration throughout each press run is of the utmost importance. Registration can be checked during a color run if you leave the acetate sheet attached.

SCREEN PRINTING TECHNIQUES At this point you are ready to begin printing. Here we have found that techniques vary somewhat even among experts. For example, some indicate that the squeegee should be drawn across the screen from top to bottom only (never in both directions), that only one squeegee pass should be used, that the squeegee should be drawn at a 70-degree angle with the screen mesh surface and so on. We feel that it is difficult to provide such hard and fast rules. However, you should make every effort to use the printing techniques you determine to be most suitable for you, while at the same time yielding the quality of print that you desire. Thus, if you find that an 85-degree squeegee angle is best for you and

produces suitable results—use it. If you find that for one sheet you draw the squeegee from top to bottom over the screen, and then for the next sheet you draw the squeegee in the opposite direction, and that the results are satisfactory, then use that procedure. Certainly, experimentation is necessary if you want to discover the capabilities of the silk-screen medium.

During printing you may experience different printing problems. For example, some inks will dry on the screen while printing, clogging the mesh and causing broken images. This might be solved by further extending the ink, by merely cleaning the screen mesh periodically or by the use of special compounds that are sold for this purpose. You might find that your images are fuzzy at the edges. To solve this problem may require changing the paper stock to one that is less absorbent, or mixing a thicker ink or perhaps pressing down more firmly in those areas when passing the squeegee across the screen. The problems that you might experience are too numerous to mention here. We recommend that you use common sense and perhaps consult a good book on silk-screen printing for solutions to technical problems. With some experience in silk-screen printing, the procedures will become routine, and minor difficulties will be solved by altering your procedures slightly.

If printing a single color image, no thought need be given to the overlapping of colors, or to color registration. However, if printing two or more colors on the same sheet in register, as with the posterized image, you should always run a larger number of sheets of the first printed color than needed for the final number of desired prints, as some will undoubtedly be spoiled during the subsequent color printings. When printing more complicated images, run the colors in a specific sequence—light to dark (as in posterizations), or dark to light to achieve a particular effect. Planning is an important part of multiple-color printing.

If you find that you must stop during a press run, and do not want to clean up, you might find either of the following procedures satisfactory for keeping the ink from drying and clogging the screen mesh. The first technique is to squeegee across the printing area without ink thereby forcing the ink already in the mesh onto a blank sheet of scrap paper or newspaper. Two or three passes should clean the screen fairly well. The second technique is to flood the image area with a heavy coat of ink which will not dry quickly because of its thickness. When ready to begin printing again, squeegee lightly across the top of the screen and gather the ink together along the desired edge, then begin printing.

The number of impressions you might expect from a particular stencil will vary with the thickness of the emulsion deposited on the screen when it was originally made, with the amount of squeegee pressure exerted when printing, with the size of areas of

fine detail (they will be lost more quickly than less detailed areas), with the number of times the screen has been washed up, with the solvents used for washup, and so on. Instead of offering hard and

Four-tone posterization entitled Formal Sitting. The printers used to make posterizations can be used to make silk-screen stencils.

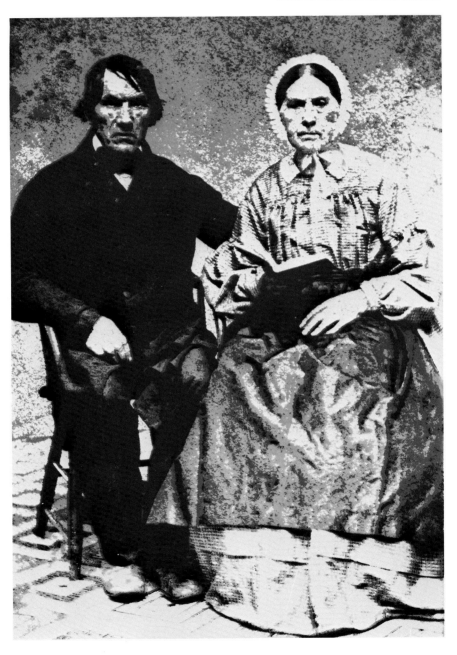

fast rules in this area, we feel it is best to experiment to determine the printing techniques that yield optimum results. The chart on pages 136 and 137 provides comparative information on the five different types of stencils.

Begin cleanup by removing all salvageable ink from the screen with a piece of cardboard or mat board, and placing it into a container for storage. Seal the container well.

CLEANUP PROCEDURE

Place a thick section of newspaper under the screen to absorb all cleanup solvent and pour a small amount of the solvent into the center of the screen. Take a few sheets of paper towel and soak up some of the solution, then rub the towel on the screen surface allowing the solvent to penetrate the screen mesh and dissolve the ink. After the newsprint and towels become saturated with ink, discard them and use clean newspaper and towels to continue the cleaning process. After most of the ink has been removed, separate the screen from the hinges or clamps, and wipe the back and front of the screen mesh until all residual ink has been removed. Try to get all ink out of the screen mesh, as well as from the paper-tape areas and the frame. Also remember to clean the squeegee well.

When you are ready to remove the photo-silk-screen image completely, begin by soaking the screen in a warm water bath. This will remove the water-soluble blockout and begin to loosen the film emulsion. Then, while the screen mesh is still wet, sprinkle enzyme cleaner over the entire film image, and rub it into a wet paste. Allow this paste to remain on the screen mesh for a few minutes, then rinse the enzyme cleaner off the screen with warm water, using a light scrubbing motion to remove the more stubborn areas. Repeat the process if necessary, until the entire film image has been removed. We have found that enzyme cleaner is most effective in removing the photographic silk-screen image quickly; a possible substitute might be Ajax cleanser. It requires more rubbing though, and is not as powerful for photo-stencil removal as is the enzyme product.

REMOVING THE PHOTO-SILK-SCREEN STENCIL

One word of caution concerning enzyme cleaners. Be sure that you rinse the screen mesh very well with water, as some enzyme cleaners have a tendency to eat away the silk mesh. Even though we have found that ample washing provides good enzyme removal, sometimes a weak acid wash with vinegar may be needed to neutralize the enzyme cleaner completely.

After complete removal of the photo-silk-screen image, you may find a "ghost" image remaining on the screen. Often this residual image is not removable, since it is simply a stain in the screen mesh. This will not adversely affect the use of the screen for the next image. In some cases, however, the "ghost" image is a deposit of dried ink clogging the screen mesh and must be

removed before using the screen for the next image. This removal is easily accomplished by scrubbing the screen thoroughly with lacquer thinner, holding the screen in a vertical position and rubbing simultaneously on both sides with rags or paper towels soaked in the solvent.

It is most important that the screen mesh is completely free of oil, grease and solvent, as well as residual enzymes, so that the adhering of the next photo-silk-screen image may be done without difficulty. This may be accomplished with a final wash of the screen with clean water, wetting the mesh thoroughly. It should then be allowed to air dry. Careful handling of the screen is important as even oily deposits from your hands may cause problems when adhering a new image.

The silk-screen mesh itself will last for hundreds of impressions, of many different images, if properly cleaned and used. A new mesh may have a different run potential, because of the many variables of the stencils, printing and cleanup procedures utilized. As you work with the silk screen, at some point the mesh will begin to fray or tear in certain areas, or it may begin to produce fuzzy image edges. When this happens, the mesh should be changed and new mesh stretched over the frame using the procedures described at the beginning of this chapter. We have found it advisable to keep spare mesh available at all times so that a screen can be changed immediately if necessary.

We have found the photo-silk-screen technique to be an excellent method for producing the posterized image in various colors rather than in tones of gray as discussed in Chapter V. Posterizations are very exciting when done by this technique, because of the infinite variety of colors available, the large range of sizes which may be produced and the excellent detail which can be carried from the high-contrast lith film separation to the printed sheet. Silk screening of the four-tone posterization, with careful color selection, produces an exciting posterized image.

Creative Photographic Color Printing VIII

Within the past few years some simplified photographic color systems have become available. Since this book deals with creative photography, it would not be complete without some discussion of the possibility of applying photographic color to some of the previously described procedures. Some of the techniques indicated, such as posterization, are particularly suited to color experimentation. Earlier we indicated that the posterized photograph contains different values from black to white (a four-tone posterization contains black, white, light gray and dark gray). The addition of color to the posterization technique adds another dimension to the process. Photo-silk-screening is one way to apply color to the creative image. Photographic color printing is another technique to explore.

We have found that the Unicolor System (KMS Industries) is effective and troublefree for making creative color photographs. The Unicolor process, like other color printing systems, is designed primarily to print conventional color pictures using appropriate color filters, paper and chemicals. The Unicolor system is also easily adapted to the production of the more unusual color images we are making.

UNICOLOR SYSTEM

For this color printing technique an enlarger is necessary to project the image, or to provide a light source for contact printing. Equipment to be used will include an accurate timer and an appropriate color filtration system with at least red, blue and green filters. Color printing paper, development chemistry and the proper processing equipment will also be necessary. For our discussion we will use Unicolor paper, developer, "blix", stabilizer and the Unicolor drum for processing.

Most of the printing we will be doing requires the production of several images in register, as in the case of posterizations. This is done by contact printing on color paper, using different filters to produce the desired colors and pin registration to maintain the position of the several images. While contact printing requires making the originals in the full size of the final print, it facilitates register; few enlargers have the means for precisely registering

Equipment necessary for Unicolor color printing.

Development timer

Color chemicals

Unicolor drum

Measuring cup for color chemicals

small negatives. Enlargement can be used where high-contrast images are to be printed in a single color on paper.

COLOR FILTRATION The color printing techniques to be used here will be done in total darkness, exposing through filters onto a sheet of color printing paper. The additive exposure sequence makes use of red, blue and green filters, and produces exceptionally good results. It is important to remember that the color filters produce complementary colors on the paper as follows:

The blue filter produces a yellow color.

The green filter produces a magenta (red-blue) color.

The red filter produces a cyan (blue-green) color.

The order of exposure with filters will have some bearing on the final color results. Conventional color printing requires that the exposures follow the blue-green-red sequence. However, variations in color may be produced by changing the time of exposure for each filter, and to a degree, the order in which the images are printed.

It is possible to expose a single original image through more than one filter. For instance, when doing a posterization you may decide to expose one negative separation to a green filter for 10 seconds followed by a blue-filter exposure for 15 seconds. Since the green-filter exposure would produce a magenta color, and the blue-filter exposure a yellow, the two combined will produce a red or orange, depending on the ratio of the two exposures. The red, green and blue separation filters cannot be used in pairs in the holder; they will simply be opaque.

Just prior to exposure, the developing tank (Unicolor calls it a "Unidrum") should be filled with water at a temperature of about 94°F. The drum allows complete processing of the exposed print under normal room lighting conditions, which simplifies the development procedure. Complete processing instructions for both drum and tray procedures, similar to the method presented here for 8″ × 10″ prints, are included with the Unicolor chemical package.

Continuing to work in total darkness, the paper is removed from the contacting board after exposure and quickly slid into the water-filled developing tank. The edges of the paper will fit snugly into the guides built into the tank walls. After the sheet is inside the tank and immersed in the water bath, the tank top is attached. At this point the darkroom lights may be turned on and all processing completed under normal room lighting.

PROCESSING CHEMISTRY

Three chemical solutions are required for Unicolor paper processing—developer, bleach-fix (called "blix") and stabilizer. After the exposed color print has soaked for one minute, the warm water is poured into a container so that some of it can be used later for rinsing. At this point you have an undeveloped color print, presoaked in water and ready for development.

Pour 2 ounces of paper developer into the drum. Then roll the drum back and forth briskly on a flat surface. This provides uniform agitation because of the special drum construction. The development rocking period should be 2 minutes, and when completed, the solution is poured out of the tank. Follow immediately with 2 clean water washes, using 4 to 8 ounces of the salvaged warm water each time. Each wash should last 30 seconds.

The second step in processing is now begun by measuring out two ounces of "blix" and pouring it into the drum. It is then rocked for two minutes, after which the "blix" solution is poured out. A second rinsing procedure, using 4 to 8 ounces of salvaged warm water changed twice, follows. At this point, the lid of the drum is removed and the print is inspected in the tank. If the image is not acceptable it may be discarded and a new exposure made. If the image is acceptable, a final 2-minute water rinse, with agitation and water changes, is given. Processing time, including the final washing, is about 8 minutes so far.

The third and last processing step is necessary to keep the print from fading. We usually use a photographic tray large enough to accommodate the print for the stabilizing solution. After the print has been washed for the final 2-minute period, it is removed from the drum and immersed in the stabilizer bath for approximately 1 minute, and agitated. Prints are then dried under low heat as they come from the stabilizer solution; they are not washed further.

TIME AND TEMPERATURE It might be well to note a few important points concerning color printing as described here. Time and temperature both affect the final print. We have found that controlling development time and developer temperature requires close attention, but if the temperature of the darkroom does not vary considerably from day to day and time is controlled fairly accurately, problems in this area will be minimal. Final results will be affected, however, if either deviates very far from the specified values.

Thousands upon thousands of color combinations are possible with this type of color printing system. You should experiment with the various filter combinations and exposure variations while keeping processing as standardized as possible. One simple procedure to help you remember what colors can be produced with the various filters is to contact print the filters on a sheet of color paper using a basic exposure (perhaps 15 seconds at $f/32$ with a 150mm lens), then use that print to determine the colors you desire. You will find this system especially valuable if you are using a large number of different filters.

RECORD KEEPING If you wish to repeat your results, be sure that you keep accurate, detailed records of exposure times, filters, and other data on each print you produce. You should include in your records the filters used and the order of exposure, together with the film images used and their sequence of use. Also, exposure times and apertures must be accurately recorded. (This information should be written very lightly in pencil on the back of the print after it is dry.) In addition to making records of exposure, it is a good idea to save the results of your experiments, even if unsuccessful, as they may suggest possible future use of those filter combinations and exposure times.

The colors seen in wet prints change slightly as the prints dry, but we have found that with prints made on Unicolor paper, there is not much color shift between the wet and the dry prints. Other processes and papers may change more as the print dries.

PRODUCING POSTERIZATIONS As previously mentioned, one application for this color printing process is the posterized image. Other interesting possibilities also exist for contact- or projection-printing combinations of high-contrast images. Combinations of line conversions, line and bas-relief imagery, and other supplementary effects on lith film may also be utilized.

In our work with various color-image combinations we often experiment with placement of certain images in specific positions on the color paper sheet so that several forms or images will combine in a preconceived manner for the completed composition. To this end, we have used the 3M Company Color-Keys (basic use and processing of Color-Key material is discussed in

Chapter VI). Color-Key is used primarily for color proofing in the graphic arts industry, but its images, when placed in contact with color printing paper, provide a "direct contact filter," simultaneously imparting both color and shape to the color print. The enlarger is used to make the white-light exposure of the Color-Keys on the paper.

It is possible to make your own color-filter system from available Color-Keys; a variety of colors may be purchased together in the Rainbow Pack. To make Color-Key filters, the unprocessed Color-Key material should be cut into small squares to fit your enlarger filter holder, then taped into cardboard mounts of your own design. We have found that these special filters allow us to obtain, with one exposure, colors which normally require several exposures through the basic red, blue and green filters.

Another variation of the color printing technique is the production of color photograms. The black-and-white photogram technique, to produce high-contrast lith film photograms, is described in Chapter III. Color photograms may be made from almost any colored transparent or translucent object placed in direct contact with the color printing paper, using the enlarger to provide the exposure. Such objects may also impart various texture patterns that can add to the final effect. Color filters can also be used.

It is also possible to make use of texture-screen patterns with film images and color printing paper to produce texture in selected areas of the color print. Basic information on the use of texture screens will be found in Chapter VI.

Glossary

amber safelight—an orange-brown (Kodak Wratten Series OC or DuPont S55X) safelight filter used with many black-and-white projection and contact papers

Amberlith—a masking film made by the Ulano Company, amber in color and used for mechanical masking of materials which are not sensitive to yellow light

aperture—adjustable opening through which light passes in a camera or enlarger lens

antihalation layer—a coating of dye material on lith film (and other types) which prevents internal light reflection from the base of the film back to the emulsion

Aquafilm—a type of knife-cut silk-screen film (Ulano) which is adhered to, and removed from, the silk-screen mesh with water, isopropyl alcohol or vinegar

ASA exposure index—speed rating for film emulsions developed by the American Standards Association

Autoscreen film—an orthochromatic Kodak film designed to produce a screened image from continuous-tone copy without the aid of a halftone screen

bas-relief—a type of image resembling low sculptural relief; made by placing a high-contrast negative and positive in contact, but slightly out-of-register

base side—the side of the film sheet which is not coated with a light-sensitive emulsion; always the dark side with lith films

base-to-base contacting—a contact-printing procedure for producing a line conversion in which the emulsion sides of two sheets of film face away from each other

bleed—a term used to describe a high-contrast image which has been overexposed, and after development, has black areas spreading into the white areas

burn—a term used to describe the undesirable loss of knife-cut stencil image from too much adhering fluid; also used to describe the exposure of photo-silk-screen film and other photographic products with an intense (usually ultraviolet) light source

chemical fog—undesirable density in clear film areas, not caused
 by exposure

Chromium intensifier—a product used to increase the contrast or
 density of film images

Color-Key—a product manufactured by the 3M Company for color
 proofing and other applications in the graphic arts;
 basically a pigmented photo-sensitive coating on a poly-
 ester support; it is exposed with an intense ultraviolet
 light source and developed by washing out the unex-
 posed part of the coating

composite negative—a negative made by the posterization process
 from the high-contrast film positive separations; contains
 all the tonal values of the posterized image, but in reverse
 tonality

contact exposure—the exposure used when contacting two pieces
 of film or a sheet of film and paper to one another

contacting—the production of a film or paper image by exposing
 through a full-size film negative or positive placed in
 direct contact with a sheet of unexposed film or paper

contrast—the degree of difference between the darkest shadows
 and brightest highlights in an image

continuous tone—images on film and paper containing a range of
 values from white through gray to black

Dektol—a Kodak developer for papers; roughly corresponds to
 Kodak D-72 developer

density—measure of opacity; also see gamma

development temperature—the temperature recommended for the
 most satisfactory development of a film or paper im-
 age—usually 68°F. (20°C.) with lith films

development time—the amount of time recommended for the
 production of normal density on a film or paper image—
 usually 2$^{1}/_{2}$ minutes with lith film developer

dot screen tint—a pattern of dots, all of the same size, imaged on a
 sheet of film and used to reduce a solid black into what
 appears to be a gray

emulsion—the coating on a film or paper support, composed of
 light-sensitive salts suspended in gelatin

emulsion-to-emulsion—printing when the emulsion of the nega-
 tive or positive is in contact with the emulsion of the
 unexposed film or paper; generally used to ensure maxi-
 mum sharpness and detail

enzyme cleaner—a product used to aid in the removal of photo-
 stencil images from the silk-screen mesh

Farmer's Reducer—a mixture of sodium thiosulfate and potassi-
 um ferricyanide used to remove part of the silver from a
 photographic film or paper image, thus reducing density

film base—the support for light-sensitive emulsions in photo-

graphic films; usually polyester, acetate or other plastic; also called film support

film speed—also called emulsion speed or ASA; the rating of a film's sensitivity to light

filter—a piece of colored glass, film or gelatin used to separate colors or vary the contrast of an image

fixing bath—also called hypo; a photographic solution which halts the action of the developer and dissolves the unexposed silver particles

flashing—re-exposing a print to white light prior to, or during, development; creates a pseudo-solarization effect

gamma—measure of development contrast

halftone—photographic images in which the continuous-tone image is photographed through a ruled screen to break the image into dots of various sizes

high contrast—a film or paper image which contains only black and white values

High Contrast Copy Film—a Kodak high-contrast panchromatic film used for the photographic reproduction of manuscripts, drawings, letters and other graphic material

highlight areas—the lightest areas in the positive image; they appear darkest on the negative image; also see shadow areas

hypo—a photographic solution which halts the action of the developer and dissolves the unexposed silver particles; also see fixing bath

lacquer film—a type of knife-cut silk-screen stencil film consisting of a thin layer of lacquer coated on a polyester or paper support; adhered to and removed from the screen mesh with lacquer thinner

light table—a table which has a translucent glass top with a white light underneath; useful for registration or correction of film negatives and positives

line conversion—the photographic production of a line image, through base-to-base contact printing of a same-size high-contrast negative and positive image

lith developer—a developer which is used especially for processing lith films; it produces very contrasty results

lith film—short-scale films made for the graphic arts industry; may be orthochromatic or panchromatic

long-scale film—a film having an emulsion that will record a wide range of tonal values

Mackie Line—the line formed around image areas during the Sabattier Effect technique due to the release of bromide ions from the film emulsion

masking—the selective blocking out of image areas

mechanical masking—hand cutting a mask to block image areas

middle-tone—term used to describe an average or "middle" rendering of a continuous-tone image; also used to describe this "middle" rendering when producing the posterization separations

multiple image—various images used together to create a final image

negative—an image with the original tone values reversed; can be on paper or film

negative-acting—producing opposite tonality; white becomes black and black becomes white

negative carrier—a metal or glass holder used in conjunction with the darkroom enlarger to hold the negative flat during exposure

opaque—a liquid coating used to paint out or cover up film areas that should be opaque

orthochromatic—a term used to describe films (such as lith films) and papers whose emulsion is sensitive to all colors except red

overexposure—excessive exposure of a film or paper image causing too much density, along with image bleeding and associated problems

panchromatic—a term used to describe film or paper emulsions which are sensitive to all colors

paper negative—reversals produced from exposures with processed and washed prints which are placed in direct contact with an unexposed paper sheet; the printed image thus serves as a mask during the exposure

paper stencil—a type of stencil cut or torn out of paper for silk-screen printing

pastel projection paper—photographic printing paper that is manufactured on a tinted base; it is exposed and processed like conventional black-and-white printing paper

photogram—a photographic image made by placement of materials or elements directly on the photo-sensitive paper or film, and exposed to light; a shadow image

photo-silk-screen film—provides a stencil by exposure to a positive image using an intense ultraviolet light source; after development, unexposed portions are washed away and the gelatin remaining is then adhered to the screen mesh

pinholes—small transparent holes in otherwise opaque portions of a film negative or positive; usually from dust or dirt on the film or exposure equipment

pin register—a technique in which film images are positioned on metal or plastic pins for repeated, exact alignment

Polycontrast—a popular Kodak projection paper that may be used for black-and-white enlargements or contact printing; Polycontrast filters are used when printing continuous-

tone images to control contrast; film images of normal contrast can be printed without a filter

positive—an image which duplicates the values present in the original scene; can be on film or paper

positive-acting—photographic materials which produce a positive from a positive, or a negative from a negative

posterization—a technique whereby a photographic image is divided into several distinct shades of tone and printed in register to produce a single image that contains only those tonal values

pre-exposure punching—one type of pin registration where all unexposed films to be registered are punched prior to exposure; exposure and all other work is then done using pins as register guides

press run—term used to describe the printing of one color of an image using the silk-screen procedure; other colors are printed with other press runs

printers—term used to describe the various separations in posterization; also used to describe the different screens to be printed in producing a silk-screen image

proof-sheet technique—exposure of a large group of negatives on a single sheet of film, to produce high-contrast positives in strips; these are then cut apart for use. The same technique can be used for continuous-tone negatives

projection—enlargement of a photographic image by exposure through a lens

red enlarger filter—placed in the filter holder and used in front of the enlarger lens to protect the paper while it is being aligned

red safelights—safelight suitable for working with orthochromatic film and paper emulsions; Kodak Wratten Safelight Series 1A and others

Rubylith—a masking film made by the Ulano Company which is red in color; used for mechanical masking of materials that are not sensitive to red light

Sabattier Effect—a technique of producing a line rendition of a photographic image by re-exposing the lith film while development is taking place

screen frame—used to hold the silk-screen mesh tightly during printing; may be made of wood or metal

screen mesh—the material used to support the stencil in silk-screen printing; may be made of silk, nylon, polyester, stainless steel or other materials; normal silk mesh grades are 12XX and 14XX

screen tint—high-contrast or continuous-tone patterns on film; can be used with high-contrast images to modify tones; also see dot screen tint and special-effect screen tint

selective solarization—a technique utilizing a mask placed on the partially developed print and then re-exposed

separation—negatives or positives made at different exposure levels; used in the making of a posterization

shadow areas—the darkest areas in the subject; they appear lightest on the negative image

short-scale film—a film having an emulsion that produces high-contrast images

solarization—used to describe the technique of re-exposure of a print to white light during development

special-effect screen tint—films printed with a variety of different patterns; used to produce a texture effect with film images

squeegee—a rubber- or plastic-bladed wooden device used to spread silk-screen ink smoothly through the open mesh areas during a press run

stencil—term used to describe the mask prepared for silk-screen printing

still development—process whereby film is developed without agitation of the tank or tray; used in producing Sabattier-Effect

stop bath—a bath of dilute acetic acid used to stop the action of the developer; used with both films and papers

sun-lamp exposure—use of a mercury-vapor lamp to provide ultraviolet light for exposure of photo-silk-screen film and Color-Key materials

tab-pin register—a type of pin registration whereby different separations are first produced in rough alignment then registered exactly by visual means using pins, clear tape and tabs

test strip—a procedure used to determine appropriate exposure times for photographic images by producing a series of exposure steps on paper or film

texture screens—see special-effect screen tint

thin negative—a film image having little density

thumbtack rotation—technique whereby a print is rotated on a thumbtack taped, point up, under the paper easel or contacting board during exposure; a lazy susan may also be used for this procedure

tonal levels—also called separations or printers; describes the levels of exposure that translate into various tonal separations of a posterization

toners—chemical baths used to alter the normal color of photographic prints

transfer letters—letters on acetate that can be transferred to paper or film for use with other image elements

transmission—term generally used to measure the amount of light

that passes through a film image

transparent base extender—a product used for the dilution of silk-screen inks so that their color is not changed as their covering ability is increased

tusche-glue stencil—a free-hand stencil produced directly on the screen mesh; image is drawn or painted in tusche, then the mesh is covered with glue; tusche is washed out and printing done through open screen areas

ultraviolet—a band of light waves below the visible spectrum that is used to expose photo-silk-screen films and Color-Key materials

underexposure—insufficient exposure given to a film or paper sheet, producing a lack of density in the image

Unicolor—a color printing process (KMS Industries) used for making color prints with various filter and exposure combinations

vacuum printing easel—a printing frame that uses a vacuum to hold photographic materials tightly on its surface

value—generally used to mean a given tone in a photographic image

water-soluble blockout—a liquid solution applied to the screen mesh to hold back or block out areas that are not to be printed in silk screening

w tab register system—term describing the use of w-shaped tabs for register of images in silk-screen printing

Index